LEGENDARY LOCALS

OF

THE CHAUTAUQUA LAKE REGION

NEW YORK

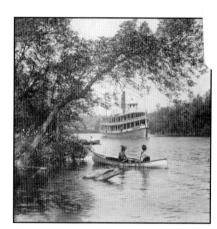

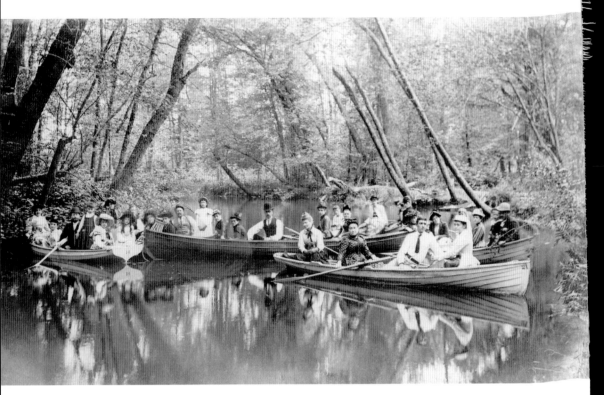

An Outing on the Big Inlet at Hartfield
This picturesque setting has long been a photographer's paradise, as illustrated by the bride and groom in the right foreground of this image. (Chautauqua County Historical Society.)

Page 1: Steamer *City of Jamestown* in the Outlet
Steamer passengers and pleasure boaters encountered countless ducks, geese, cranes, swans, and herons in the enchanting Chautauqua Lake Outlet, a three-mile narrow passage from the Jamestown boat landing to Fluvanna. (Sydney S. Baker.)

LEGENDARY LOCALS

OF

THE CHAUTAUQUA LAKE REGION

NEW YORK

KATHLEEN CROCKER AND JANE CURRIE

LEGENDARY
LOCALS

Legendary Locals is an imprint of Arcadia Publishing
Charleston, South Carolina

Printed in the United States of America

Library of Congress Control Number: 2012930630

For all general information, please contact Arcadia Publishing:
Telephone 843-853-2070
Fax 843-853-0044
E-mail sales@arcadiapublishing.com
For customer service and orders:
Toll-Free 1-888-313-2665

Visit us on the Internet at www.arcadiapublishing.com

Dedication

If you would not be forgotten, as soon as you are dead . . . either write things worth reading, or do things worth the writing.

—Benjamin Franklin

On the Cover: From left to right:
(TOP ROW) Bradley Anderson, cartoonist (*Post-Journal*, page 82); Francis K. Holmes, teacher (Jane Currie, page 39); Frederick Law Olmsted, landscape artist (The National Park Service, Frederick Law Olmsted National Historic Site, page 35); Catherine Dickes Harris, abolitionist (*Post-Journal*, page 83); Jim Roselle, broadcaster (Douglas Spaulding, page 80).
(MIDDLE ROW) Donald "Spike" Kelderhouse, fishing guide (Jane Currie, page 47); Betty Weakland Bixby, evangelist (Bonnie S. Anderson, page 71); Arthur A. Bestor, Chautauqua Institution president, and Amelia Earhart, guest lecturer (Chautauqua Institution Archives, Oliver Archives Center, page 118); Ronald Graham, mentor (Chautauqua Region Community Foundation, page 73); Charlotte Lenhart Johnston, hotel proprietor (Lenhart family, page 51).
(BOTTOM ROW) Elizabeth Warner Marvin, philanthropist (*Post-Journal*, page 71); Roger Tory Peterson, naturalist/educator (The Roger Tory Peterson Institute of Natural History, page 78); Fred and Gertrude Holbrook Cook, aviators/teachers (Mary Jane Cook Gerring, page 42); Robert H. Jackson, Supreme Court justice (The Robert H. Jackson Center, page 87); Natalie Merchant, vocalist/lyricist (Mark Seliger, page 94).

CONTENTS

ACKNOWLEDGMENTS

Our sincere appreciation to our invaluable technical assistants Pamela Berndt Arnold and Peggy Snyder, the many professional organizations and agencies who were generous with their collections and knowledge, and all those who made the effort to share their family histories with us. The names of those who provided images appear in the respective caption.

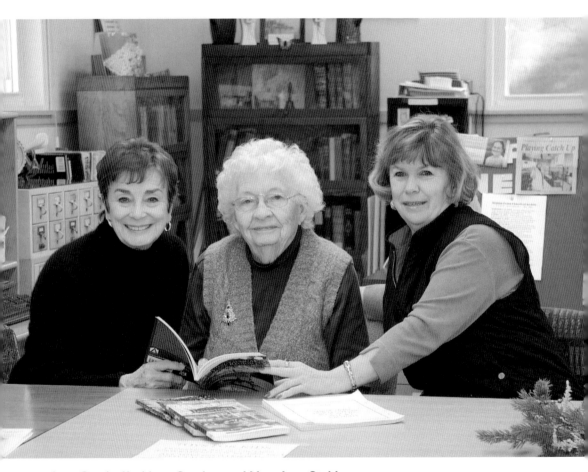

Jane Currie, Kathleen Crocker, and Mary Jane Stahley
Authors Jane Currie (left) and Kathleen Crocker (right) visit recently retired Bemus Point librarian Mary Jane Stahley, whose contributions to their Arcadia publications have been invaluable. (Pamela Berndt Arnold.)

INTRODUCTION

Throughout the 2011 Chautauqua County Bicentennial celebration, publications related to the county's history and people were highlighted. We're extremely proud that our four books in Arcadia Publishing's Images of America series were among them: *Chautauqua Institution, 1874–1974* (2001), *Chautauqua Lake Region* (2002), *Jamestown* (2004), and *Westfield* (2006). After a seven-year hiatus, we're delighted to work again with Arcadia; their new Legendary Locals imprint affords us the opportunity to present a sampling of both historic and contemporary individuals who have left discernible imprints on the Chautauqua Lake region. Whether natives, lifelong or temporary residents, or honored guests of this corner of southwestern New York State, each is worthy of recognition for his or her contributions or individuality. The celebrities, heroes, and legends we honor here are associated with one or more of the 13 lakeside communities that currently maintain US Post Office branches. In addition to many familiar names from the Chautauqua Institution, Mayville, Bemus Point, and Jamestown, we have highlighted men and women from the nine smaller communities who have also impacted our county's history. (See map, page 10.)

This is by far our most ambitious endeavor. We've conducted countless face-to-face interviews, sitting at kitchen and dining room tables spread with heirloom scrapbooks, Bibles, and photograph albums. We've been overwhelmed by the hospitality and generosity of everyone who eagerly shared family stories with us and provided candid glimpses into bygone days around the lake. We've been amazed at the number of ordinary citizens who, for us, were buried in the past but whose contributions warrant recognition beyond their own hamlets. In a limited space, we could include only those images of the finest quality, regardless of an individual's accomplishments. We've made every effort to mirror the enthusiasm of the second- and third-generation family members from whom we've gleaned much information. We regret any obvious omissions and, as always, have made every effort to ensure accuracy.

Our county's history begins with the Holland Land Company, absentee landlords representing six Dutch banking houses, which acquired property from Robert Morris after the Seneca Indians relinquished their land claims to him in the Big Tree Treaty of 1797. More than three million acres of land in western New York were purchased, about 1,000 square miles of which were located in what later became Chautauqua County. The abundance of natural resources in that vast tract of land and in Chautauqua Lake, in particular, attracted pioneer families to the area. John Luensman, former Chautauqua County planning director, considered the lake's lure to be threefold: "a transportation route [between the Great Lakes and the Gulf of Mexico], a fishing place and a recreation source." Town of Harmony historian Floyd Darrow noted that the Chautauqua Lake region has been a perennial habitat for fish and wildlife and that "the woods abounded in game, the lake with muskellunge . . . and the streams with brook trout, shiners and horned dace," providing sustenance for the pioneer fishermen and hunters and recreation for future generations. For over 200 years, the region's moderate climate and incomparable beauty have continued to lure people.

By the early 1820s, scores of settlers and their families had migrated westward en masse, primarily from eastern seaboard states, specifically from Rensselaer County, New York, bordering Vermont and Massachusetts. Arriving a few decades prior to the majority of Swedish, Irish, German, Danish, Italian, Greek, and Albanian immigrants, these families, who traced their ancestry back to England and Scotland, did not start from scratch in the Chautauqua wilderness but rather brought with them from New England and various other settled locations their farming and business acumen. In 1891, Davis H. Waite, editor of the *Jamestown Journal*, wrote: "The early settlers with their sturdy independence, their courage, activity and energy left friends and kindred to hew out for themselves homes in the dense forests of Chautauqua County. They brought with them not only stout hands and hearts, but good, honest principles and sound morals; and laid the foundation of that intelligent thrift and prosperity and

gave their lives, a living sacrifice to the accomplishment of one great thing, securing a home for future generations. Their monuments are the broad fields which they cleared. Their heirs are the inhabitants for all time to come." Noted Jamestown attorney Eleazer Greene echoed Waite's sentiments, describing these pioneers as "well educated, of high character . . . strong and vigorous physically and intellectually . . . industrious, persevering, determined. They came with a fixed purpose—to transfer the wilderness into a community of comfortable Christian homes for themselves and posterity."

Settlers contracted with the Holland Land Company for a certain number of acres, joined neighbors in "raising bees" to erect log houses, and began the arduous task of clearing timber around their homesteads. Because of the abundance of hardwood forests of hemlock, maple, oak, beech, pine, and chestnut, lumbering quickly became the Chautauqua Lake region's major industry. Potash was an invaluable commodity and the only cash crop that paid one's property and taxes. After trees were burned, the ashes were gathered and, through a fairly simple process, the semisolid black salts were converted into potash or pearl ash, used to make soap, fertilizers, and glass. "For the first quarter of a century in the settlement of the county, the fires were constantly burning in the fallen timber and fallows of Chautauqua County. . . . From the hilltops along the Ridge could be seen in all directions between Lake Erie and the Pennsylvania line, great volumes of smoke constantly ascending to the clouds," wrote historian Obed Edson about this phenomenon.

Transportation routes changed the region's economy. Prior to the opening of the Erie Canal in 1825, barrels of the valuable potash were transported from sites all around the lake to Jamestown, transferred onto keelboats and flatboats at the Chadakoin, Chautauqua Lake's outlet, and shipped southward on the Allegheny River to Pittsburgh and beyond. In later years, the potash could be conveyed along the Erie Canal to Montreal, Canada, via upstate New York, and overseas to England. With the arrival of the railroad in Chautauqua County in 1851, agriculture became the county's most important industry until the end of the 19th century, when manufacturing became its rival.

Settlers had traveled west because of the superior soil in western New York; they grew wheat, corn, barley, oats, and potatoes; tended apple, pear, plum, and cherry orchards; and established dairy farms on the newly cleared land. In 1837, the Chautauqua County Agriculture Society was organized "to improve agriculture, horticulture, the household arts, and the breeding and improvement of domestic animals." William Prendergast II was its first president, and representatives came from many townships cited in this book, including Ellery, Chautauqua, Harmony, and Busti. The Patrons of Husbandry, a related agricultural fraternal organization, was said to have "scattered blessings along the path of the [Chautauqua County's] tillers of the soil." Moreover, the Chautauqua Gazette, one of the county's earliest newspapers, advertised incentives for farmers, such as "premiums" for best cultivated farms, best acre of corn, best bull, and best merino sheep, to be awarded at the annual cattle show and fair.

The period from the late 1800s through the mid-1900s is remembered as the heyday of the Chautauqua Lake region, a wondrous era when wealthy and socially prominent families primarily from Pittsburgh, Buffalo, and Cleveland summered at various destinations around the lake. In 1827, the "Great White Fleet" of majestic steamboats began operating on Chautauqua Lake, and the founding of the Chautauqua Assembly in 1874 spurred further vessel construction. By 1898, 14 steamers plied the waters daily, and eventually, a total of 60 were in operation. In 1907, 280,000 passengers were transported up and down the lake. The ease of connections and services provided by the steamboats, railroads, and trolleys resulted in the development of a great number of hotels and summer residences by the end of the century. In a relatively short time, tourism rivaled agriculture. By 1925, with the death of brothers Almet N. and Shelden B. Broadhead, the trolley and steamboat service was "pared down to what could be profitably operated" and soon fell into disrepair. Most were dismantled, scrapped, and burned, while most hotels and boardinghouses became obsolete. Improved roads and family automobiles transported vacationers to new destinations. Little industrial development adjacent to the approximately 19-mile-long lake led to an increasing number of protected wetland preserves. Today, the majority of Chautauqua Lake's 41-mile shoreline is occupied by cottages and homes.

Each pioneer village around Chautauqua Lake evolved in similar fashion. First, water sources were utilized to establish sawmills and gristmills. Although the general store was of utmost importance to villagers, special services were provided by blacksmiths, shoemakers, carriage makers, harness makers, axe makers, and carpenters. Taverns served as havens for weary travelers, while schools and churches

An Outing at Midway Park
The spacious pavilion, with its roller skating rink and dance floor, has been a Chautauqua Lake landmark since 1915. (Kathleen Crocker.)

became community hubs. Beginning in the mid-1800s, the growing numbers of immigrants became bricklayers, stonemasons, textile and metal workers, railroad laborers, ice harvesters, shipbuilders, steamboat captains, baggage masters, teachers, bankers, lawyers, grocers, doctors, and dentists.

During the county's centennial celebration a century ago, Judge Woodward, in his address to the throngs in attendance, stressed that "hardy pioneers pitched their tents by the shores of our lake. Never has the heart of progress pulsated more fiercely than at the beginning of the nineteenth century." Many surnames of those "hardy pioneers" from New England who settled around the lake resonate with us today: Prendergast, Bemus, Peacock, Griffith, Barnhart, Strunk, Cheney, Leet, Bentley, Hopson, Slayton, Stow, Scofield, Foote, Whittermore, and Sammis. Not surprisingly, these settler families "reared a goodly number of worthy sons and daughters" whose intermarriages resulted in an overwhelming number of relatives. Once united by marriage, the Prendergasts, Bemuses, Griffiths, and Cheneys often gravitated to various sites around the lake, yet remained in close proximity.

Whether the settlement maintained its rural status or evolved into a residential area or a resort, each appears to have assumed its own identity with the opening of its post office, frequently named for its founder. Although communities are a reflection of their citizens and their unique personality, American anthropologist Ruth Benedict believed that, conversely, "the life history of the individual is first and foremost an accommodation to the patterns and standards traditionally handed down in his community."

Scottish historian Thomas Carlyle wrote, "History is the essence of innumerable biographies;" Jamestown historian B. Dolores Thompson, a treasured friend and mentor, elaborated on that idea by stating that Chautauqua County's history "is not only a chronicle of events, but also a story of people with biographies of their own, equally rich and colorful. Each generation that has passed through has added another layer to the fabric, building a multi-hued and multi-textured community. Future generations will inherit a fine foundation, fashioned by pioneer spirit and plain hard work. They could have no finer legacy."

Far more than the nearly 200 individuals featured in this small volume deserve similar public recognition. We salute every person, past and present, who has made us exceptionally proud of our Chautauqua County heritage.

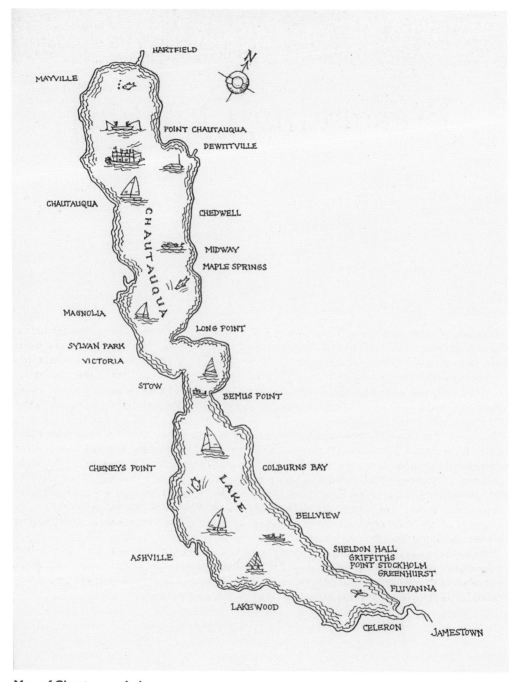

Map of Chautauqua Lake
Chautauqua Lake, approximately 18 miles long and three miles wide at its broadest, lies entirely within Chautauqua County in southwestern New York State. The individuals depicted in this book have connections to these lakeside communities. (Jane Nelson.)

CHAPTER ONE

Preserving Our Past

Thousands of volumes of Chautauqua County history are housed in repositories throughout the Chautauqua Lake region; its rich history has been preserved primarily through the diligence of amateur and professional historians, photographers, and journalists. In her presentation to the Chautauqua County Historical Society in 1920, Olive R. Schendler noted that contributions to the organization originated in "almost every part of the county," adding, "Loving hands have gathered together scattered letters and diaries, reminiscences and anecdotes to preserve them for the inspiration and instruction of the next generation."

Because it "has reported contemporary history, current information, local ideas and comments," William J. Doty, another prominent historian, believed the press "is one of the important sources of the histories of Chautauqua towns, villages and cities . . . and . . . when items printed daily or weekly . . . are preserved . . . they form a history of community that cannot be duplicated." In the 75th anniversary issue of the Jamestown *Post-Journal*, Bill Flynn agreed: "More than any other institution, a newspaper embodies the history of its area." Thus, the *Jamestown Journal*, founded in 1826, the *Mayville Sentinel* (1834), and the *Chautauquan Daily* (1876) remain precious resources because they have chronicled the history of their communities almost from their inception.

This chapter honors several historians, photographers, and newspapers for their role in permanently preserving the past. As Obed Edson wrote in his 1891 "Historical Sketch," "History is made up of the biographies of the masses, and it is best expressed in the life records of its energetic and enterprising citizens." Additional historians have been included in their respective locales.

Elial Todd Foote

Although he was a physician, county judge, postmaster, and banker, Foote's greatest contribution was his insatiable curiosity. "Judge" Foote (1796–1877) was acknowledged for doing "the most to preserve the history of [Chautauqua County] pioneer settlers and settlements." He collected documents, newspapers, assorted material, and memorabilia to share for posterity. The Foote Papers, housed in the Chautauqua County Historical Society, may also be accessed online. (From Young's *History of Chautauqua County, New York*, 1875.)

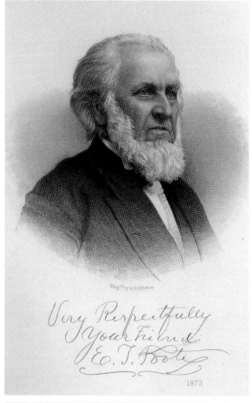

Obed E. Edson

Edson (1832–1919) was a lawyer in Sinclairville, New York, for over 60 years. A founder of the Chautauqua County Historical Society and author of several histories, he was the "best informed man of his day regarding early county history." John P. Down believed that "in the field of original historical research, [Edson] had no superior in Western New York . . . the fruits of his patient toil are fortunately gathered in permanent form." (From *History of Chautauqua County, New York*, 1894.)

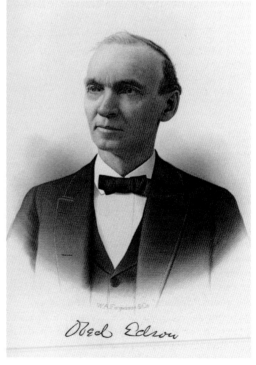

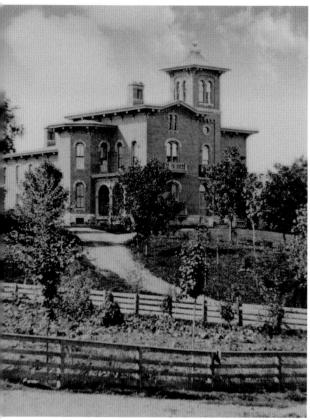

Fenton History Center
Housed in the mansion of former New York governor Reuben E. Fenton, the Fenton Historical Society, or Fenton History Center, chartered in 1964, operates as a museum and library. In addition to thousands of artifacts, photographs, manuscripts, and other items related to Chautauqua County, this Jamestown repository is highly regarded for its educational programs for area students and its extensive genealogical library, especially its collection of Swedish family records. (*Post-Journal.*)

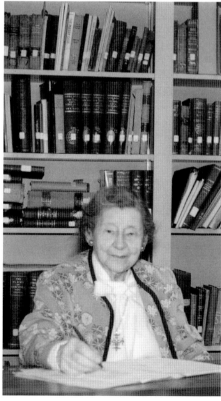

Elizabeth Crocker
Fredonia native Crocker (1894–1999) is remembered as Chautauqua County's historian from 1965 until 1999. Following her career as a physical education and health teacher, she immersed herself in the preservation of her county's history, desirous of leaving "something of value . . . to future generations." She was an active member of the Chautauqua County Historical Society, the Fenton History Center, and the Daughters of the American Revolution (DAR). (*Post-Journal.*)

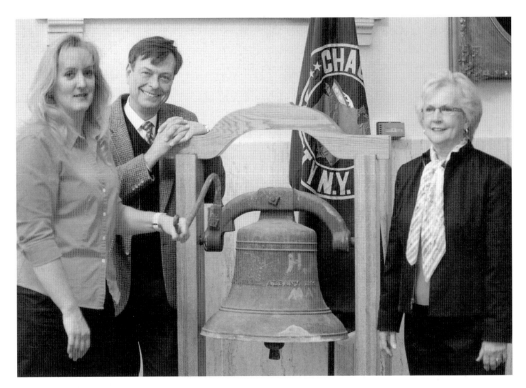

Bicentennial Celebration

Michelle Henry, Chautauqua County historian (left), James O'Brien, president of the Chautauqua County Historical Society (CCHS) (center), and county clerk Sandra Sopak pose beside a hand-forged bronze bell from the 1834 Mayville courthouse.

Chautauqua County boasts an extensive and valuable collection of vital historical records managed by the clerk's office, and the CCHS houses priceless historical records as well as artifacts. Serving as director of the CCHS, Henry, a 1989 anthropology and museums studies graduate of Arizona State University, made frequent visits to the clerk's office in Mayville to research archives. Recognizing the need to improve access to them, Sopak hired Henry as records management coordinator. Their collaborative efforts resulted in the creation of a state-of-the-art central storage facility in Mayville, and both were instrumental in the digitization and/or microfilming of millions of pages of permanent county records, including tax rolls, court case files, land records and deeds, marriage and census archives, and maps dating from 1811.

Henry's expertise has greatly impacted the preservation of the county's records and their availability to historians, genealogists, and the general public. While CCHS director from 1989 until 2000, her contributions included grant writing, archival processing, cataloging, documenting, and computerizing collections. As county historian since 2000, she has promoted an appreciation for the heritage of all 42 municipalities.

A graduate of the Rhode Island School of Design in communications and museum management, James O'Brien, from North East, Pennsylvania, has also been an asset as president of the CCHS. For the past 10 years, he has fostered its growth via building renovation projects, artifacts and archival collections, the sponsorship of 50 guest speakers and a civil rights symposium, and the creation of *TimeLines*, the society's award-winning newsletter.

Not pictured is the dedicated John Paul Wolfe, retired Cassadaga Valley Central School art teacher and art and antique restorer, who generously volunteers his talents to create exquisite exhibits at the McClurg Museum and is painstakingly rehousing each item to ensure that the museum's ever-growing collection will be available for future generations. (Niles Dening.)

John Oliver Bowman

In 1936, Bowman (1884–1977) purchased his first Kodak box camera. He received global recognition for his exhibit at the 1939 New York World's Fair. Katie Landrigan's 2007 dissertation, "The Undisputed Box-Camera Champion of the Universe," features his "peaceful, pastoral photographs" depicting daily life in Chautauqua County in the mid-20th century. His priceless collection, taken without fancy equipment, is housed in the Chautauqua County Historical Society, where he once served as director. (Chautauqua County Historical Society.)

Stanley Olson

Olson's career began at the Jamestown *Evening Journal* prior to his education at the Art Institute of Cleveland. He returned to establish the *Post-Journal*'s first photo department and, with his Speedgraphic camera, won numerous AP awards for news photography. A contemporary of Jennie Vimmerstedt and Manley Anderson, he covered resident and visiting celebrities and politicians. He was also the official photographer for Little Theater productions at the Scottish-Rite Temple. (Ina Siegfried.)

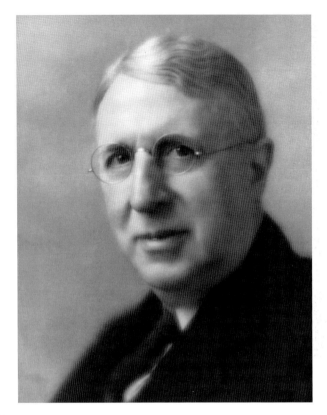

A Newspaper Dynasty

"Impressive" best describes the history of the *Jamestown Journal*, as Helen G. Ebersole's 2008 book title indicates. Unquestionably, it is "a strong city tradition—a preserver of the past, a reporter of the present." Published initially in 1826 by Adolphus Fletcher, John A. Hall's (1813–1886) purchase of the paper in 1876 established "a newspaper dynasty" that lasted several decades.

The elder Hall used his newspaper as a vehicle to serve the best interests of his community, to inform the public of local, national, and global affairs, and to use the power of the press to influence readers about "burning issues" of the day. Jamestown attorney and politician Abner Hazeltine commended Hall for his "support of all reforms the purpose of which was to improve the condition of society or to meliorate the condition of society [and] of men."

The Hall name is synonymous with the *Journal*. John and his son Frederick Perry Hall, shown here, were partners in the John A. Hall & Son firm until John's death in 1886. For the next 50 years until his death in 1939, Frederick's roles as owner, publisher, and editor helped the Jamestown *Evening Journal* transition into the modern era. In 1941, the *Evening Journal* merged with the *Morning Post* to form the Jamestown *Post-Journal*.

Following their education at prestigious institutions, three of Frederick's sons joined the family business. In 1907, Henri Mason Hall (1884–1972), a graduate of Phillips Exeter Academy and Harvard University, became treasurer and general manager of his family's Journal Printing Company. Two years later, Levant Mason Hall (1887–1975), a Williams College graduate, joined him as secretary and advertising manager. And in 1925, John A. "Jack" Hall (1903–1977) graduated from Cornell University and joined the news staff that summer. When the *Post Journal* was purchased by Ogden Newspapers in 1961, Jack remained as editor-in-chief.

The affiliations, civic undertakings, and benevolence of these Hall gentlemen are far too numerous to include here, but are a matter of public record for those who wish to learn more. (Charles T. Hall.)

Jennie Vimmerstedt
From the age of 22 until her retirement in 1975, Vimmerstedt (1904–1991) had a stellar career at the *Post-Journal*. Her specialty was reporting on club and church news, while her feature articles reflected her love of her hometown. Editor Cristie Herbst considered the veteran newspaperwoman "the heart and soul of the newsroom and our coverage of the community," while her colleague Patricia Appleyard Parker called Jennie "the grand dame of the local paper." Always helping others, Vimmerstedt went AWOL during World War II to assist the Salvation Army as program director for its servicemen's center in Philadelphia and elsewhere, but returned to her position and to renew associations with the American Scandinavian Foundation, the Political Study Club, Fortnightly, the Gebbie Foundation, the YWCA, the Girl Scouts, and the Fenton History Center, whose Swedish Heritage Room bears her name. (*Post-Journal.*)

Manley Anderson
A graduate of Bowling Green State University, the beloved Anderson began his 52-year career at the *Jamestown Post-Journal* in 1955. While covering county government and certain aspects of Jamestown's city government, he earned the respect of many for his unbiased reporting and was revered by Mayor Sam Teresi and others as "a community treasure . . . a consummate professional." His later assignments included business, industry, and agriculture. (*Post-Journal.*)

Richard W. Hallberg
Hallberg, the *Jamestown Post-Journal*'s award-winning chief photographer, was hired full time in 1948. Responsible for chronicling events, accomplishments, and scenery in the paper's circulation districts of southwestern New York and northwestern Pennsylvania, he clocked about 28,000 miles annually. His remarkable natural talent gained him access to world icons including Lucille Ball, Roger Tory Peterson, and Robert F. Kennedy, and his photographs appeared in publications throughout the United States and in Sweden. (*Post-Journal.*)

The *Mayville Sentinel*
Samuel S. Whallon, William Kibbe, and Thomas A. Osborn are credited with founding the *Mayville Sentinel*. Located in the county seat, the weekly has apprised Mayville residents and others of local news, concerns, and information pertaining to Chautauqua County government since 1834. A counterpart to the *Westfield Republican* since the establishment of the latter in 1855, both papers are owned by Ogden Newspapers and share an office in Westfield, New York. (Peter C. Flagg.)

The *Chautauquan Daily*
The *Chautauqua Assembly Daily Herald* was founded in 1876 by Theodore L. Flood as the monthly organ of the Chautauqua Literary and Scientific Circle (CLSC). Renamed the *Chautauquan Daily* in 1906, the summer newspaper reported lectures, sermons, and insightful editorials that helped spread the word about Chautauqua's unique programs. It was supplemented throughout the year by the *Chautauquan Magazine*, which contained book reviews, supplemental CLSC readings, and self-study aids. (Chautauqua Institution Archives, Oliver Archives Center.)

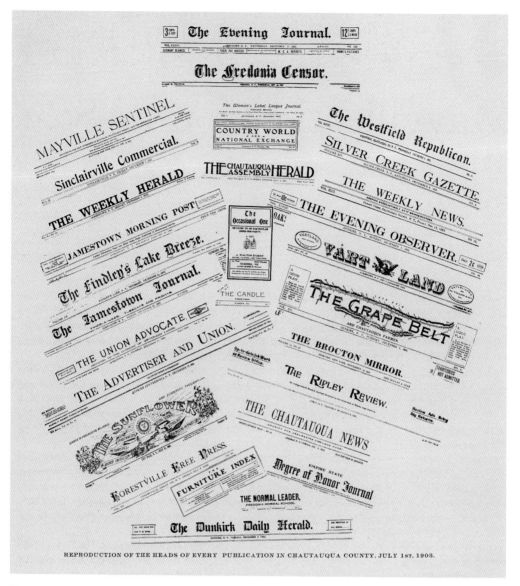

REPRODUCTION OF THE HEADS OF EVERY PUBLICATION IN CHAUTAUQUA COUNTY, JULY 1ST, 1903.

Various County Newspapers

The *Post-Journal*'s inaugural issue noted, "The intelligence and character of . . . citizens . . . may be readily ascertained from the number and character of the newspapers that circulate in [their community.]" Amazingly, about 100 newspapers were operating at one time in Chautauqua County.

Informative and educational, newspapers were vital to communities. William J. Doty knew the importance of the fourth estate: "Because the press has reported contemporary history, current information, local ideas and comment, it is one of the important sources of the histories of Chautauqua towns, villages and cities. . . . When items printed daily or weekly . . . are preserved . . . they form a history of the community that cannot be duplicated."

To ensure the inclusion of news from smaller settlements, the *Jamestown Journal* hired reporters from outlying areas. Trolleys and trains delivered newspapers to the Erie Railroad station and to hotels in Lakewood, Bemus Point, and the Chautauqua Institution. (From *Centennial History of Chautauqua County*, vol. II, 1904.)

CHAPTER TWO

Mayville, the County Seat

Chautauqua Lake was of vital importance to early explorers and settlers as a navigation link between the Great Lakes and the Gulf of Mexico. Via the original Portage Trail forged by French explorer Pierre Joseph Celoron de Blainville and his expedition in 1789, goods were once transported by oxen and horses from Barcelona, on Lake Erie, to Mayville, situated at the head of Chautauqua Lake. From there, canoes and dugouts conveyed the cargo down Chautauqua Lake to Jamestown and points south.

In 1804, Dr. Alexander McIntyre of Meadville, Pennsylvania, purchased land for his log cabin and became the first permanent settler on Chautauqua Lake. William Peacock, Holland Land Company's surveyor and agent, considered the Chautauqua Lake region "the paradise of the new world." He not only relocated his office and residence to Mayville, but, more importantly, Peacock, the future esteemed county judge and treasurer, encouraged the Prendergast family and their "imposing emigrant train" of 29 people to stake their claims nearby.

Designated the county seat in 1808, Mayville grew rapidly. Main Street, renamed Erie Street, the extension of the Old Portage Trail, became its commercial hub. In 1811, brothers Jediah and Martin Prendergast opened the village's first store, and John Scott's Tavern was the site of court sessions until dedicated buildings were erected. For nearly 200 years, county residents, including politicians, attorneys, judges, and jurors, have traveled to the majestic courthouse and government offices on Mayville's hilltop for county-related business.

In the second half of the 19th century, Mayville became Chautauqua Lake's busiest port. The Pennsylvania Railroad depot at the foot of Erie Street (now Route 394) and three massive steamboat docks handled the greatest number of arrivals and departures. Connections to the various lakeside communities were facilitated for both passengers and freight. With the founding of the nearby Chautauqua Assembly and Point Chautauqua, Mayville experienced an influx of seasonal visitors who invested in cottages, private residences, and fashionable estates overlooking the natural beauty of the upper lake and surrounding countryside.

Judge William Peacock

Historian Edson wrote that Peacock (1780–1877) was "identified with every phase of the progress of the county" and was "a faithful and honest friend" whose good deeds included donating land for the Mayville Cemetery and Academy. Unfortunately, after an angry mob of farmers, outraged by strict payment demands, stole and burned valuable land company records from his office in 1836, he was replaced as land agent by William H. Seward. (From Young's *History of Chautauqua County*, New York, 1875.)

Donald Mackenzie

When Scottish fur trader Mackenzie (1783–1851), once employed by John Jacob Astor in the Canadian Northwest, learned of the Chautauqua region's beauty, he bought a farm in Mayville and resided there from 1832 until 1851. He reportedly sequestered his friend Judge Peacock there during the assault on the Holland Land Company vault. His house was later used by the school for the agriculture class and other purposes. (From Young's *History of Chautauqua County*, New York, 1875.)

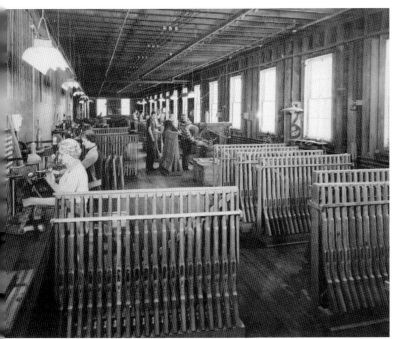

Kling Factories
Founded by Swedish immigrant John Kling in 1911, Kling Factories, a 51-year family business, employed up to 200 Mayville area residents until 1962, when it was sold to what became Ethan Allen Retail Inc. During World War II, the plant suspended furniture manufacturing to assist the war effort by producing airplane parts, hospital trays, and gunstocks, shown here with female employees. (Chautauqua Township Historical Society.)

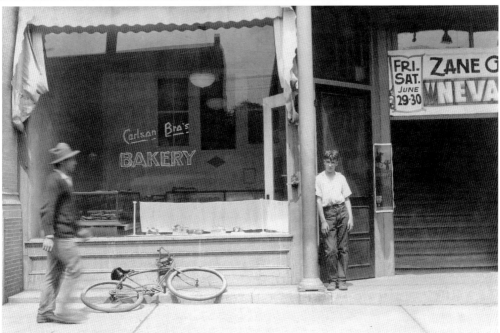

Carlson's Bakery and Theater
Young Charles "Charlie" Willson delivered for the Carlson Brothers' Bakery on Erie Street, established in 1920 by Andrew Addison Carlson (1891–1972) and his brother Harold. "Talking pictures" at the adjacent Carlson Theater attracted rural residents to the village of Mayville. As mayor for eight years, "Andy" led the development of Lakeside Park, the site of the annual Ice Castle Festival since 1987. Sons Donald and Jack were also community leaders. (Carlson family.)

Judge Albion Winegar Tourgee
Tourgee (1838–1905), a veteran lawyer, newspaperman, and former carpetbagger, settled in Mayville in 1881 to continue his crusade for civil rights. *A Fool's Errand* and other novels by Tourgee, social commentaries regarding racial prejudice and inequality, proved far more effective than his prior political activism in the South. *Button's Inn*, a novel about a Portage Road tavern, is among the extensive Tourgee Collection housed in the Chautauqua County Historical Society archives. (Chautauqua County Historical Society.)

Emma Kilbourne Tourgee
While also a writer, Emma Tourgee (1840–1915), the judge's wife, devoted her life to her husband's writing career. A member of the Tuesday Club of Mayville, founded in 1895, she bequeathed the bulk of her estate for a community library, to be located adjacent to Thorheim, the family residence on South Erie Street. She outlived both her husband and their daughter Aimee, a talented illustrator, writer, and lecturer. (Chautauqua County Historical Society.)

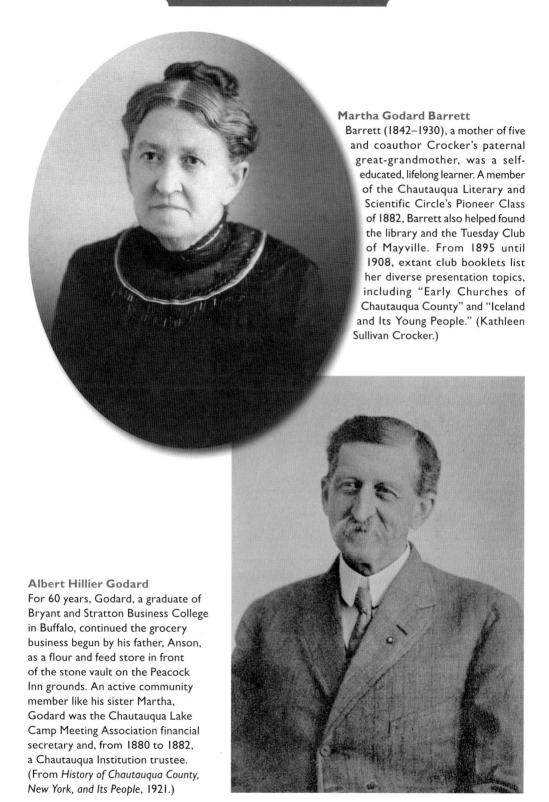

Martha Godard Barrett
Barrett (1842–1930), a mother of five and coauthor Crocker's paternal great-grandmother, was a self-educated, lifelong learner. A member of the Chautauqua Literary and Scientific Circle's Pioneer Class of 1882, Barrett also helped found the library and the Tuesday Club of Mayville. From 1895 until 1908, extant club booklets list her diverse presentation topics, including "Early Churches of Chautauqua County" and "Iceland and Its Young People." (Kathleen Sullivan Crocker.)

Albert Hillier Godard
For 60 years, Godard, a graduate of Bryant and Stratton Business College in Buffalo, continued the grocery business begun by his father, Anson, as a flour and feed store in front of the stone vault on the Peacock Inn grounds. An active community member like his sister Martha, Godard was the Chautauqua Lake Camp Meeting Association financial secretary and, from 1880 to 1882, a Chautauqua Institution trustee. (From *History of Chautauqua County, New York, and Its People*, 1921.)

Devon A. Taylor

Like his grandfather Bertrand Taylor (1890–1956), Devon Taylor has a keen interest in photography, radio communication, and historic lake transportation. Gilbert "Gib" Hayward held the position of Mayville historian, but he recommended that Taylor also succeed him as historian of the Chautauqua Township Historical Society. Taylor has written *Mayville: A View Through Time*, *Chautauqua Gorge*, and other significant historic accounts about the vicinity. (Jane Currie.)

Guy A. Taylor (1918–2012)

Guy Taylor's father, Bertrand, set up a neighborhood telegraph, family telephone system, and private telegraph line for himself. During World War II, Guy, seen here in 1942, was a radio operator assigned to the Supreme Headquarters, Allied Expeditionary Forces in Europe. One of 39 FCC-registered amateur radio operators in Mayville, Guy took great interest in preserved artifacts found in the nearby Chautauqua gorge and lake environs. (Devon Taylor.)

Mabel Powers

Born near Buffalo, New York, in 1872, Powers graduated from Buffalo State Normal School and the Shoemaker School of Elocution and Oratory in Philadelphia, Pennsylvania. In 1910, the Tonawanda Seneca Nation adopted the white woman, whom they named Yehsennohwehs, "she who carries and tells the story." Westfield historian Billie Dibble noted that Powers then dedicated herself to becoming "an earnest student of the history, customs, religion, ritual and stories of the [Iroquois] Indians."

Much of Powers's life was spent on the shores of Chautauqua Lake at Wahmeda, a tiny community close to the "wondrous" Chautauqua gorge and adjacent to the Chautauqua Institution, where she was hailed as an eloquent storyteller, often donning Native American costumes as she interpreted and extolled the values and ethical teachings of the Iroquois way of life evidenced in their tales. She wrote *Stories the Iroquois Tell Their Children* (1917), *Around an Iroquois Story Fire* (1923), and *The Portage Trail* (1924), books that mirrored her own experience.

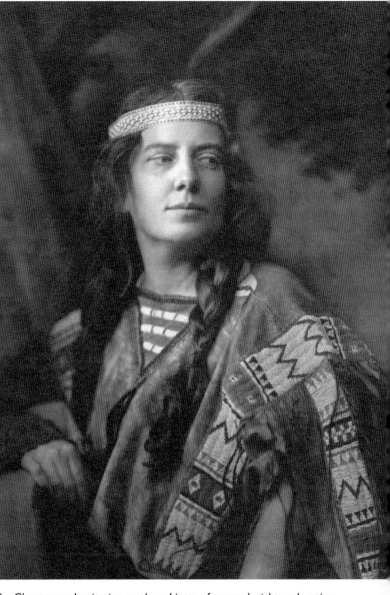

She was a frequent lecturer at the Chautauqua Institution on the subjects of women's rights, education, and world peace. Impressed by the wisdom of the treaty fashioned by the Five Nations of the Iroquois in the 1790s, she thought it "The Original American Blueprint for Peace." The treaty was undoubtedly the basis for her later work, *The Indian as Peacemaker*. Having gained national recognition for her expertise on the Six Nations of the Iroquois, Powers was invited by Jane Addams of Hull House in Chicago to represent Native American women at the World Peace Congress of the Women's International League for Peace and Freedom, held in Washington, DC, in 1924.

Chautauquans, too, continued to appreciate her talents. In 1933, the Indian Tree Pageant, sponsored by the Bird, Tree and Garden Club, was held in the south ravine on the grounds. Mrs. Thomas A. Edison, president of the organization, was most likely in that audience. Powers's collection of artifacts and publications is housed in Patterson Library in Westfield. (Patterson Library, Westfield, New York.)

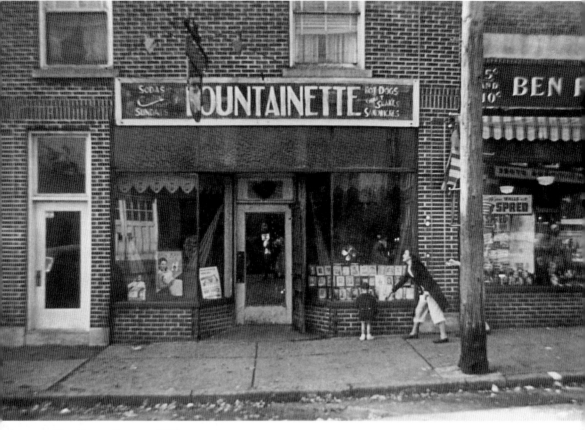

The Fountainette, 1942
Paul Webb and his childhood sweetheart, Nadine Henderson, married and opened the Fountainette, an ice cream parlor and sandwich shop on Erie Street. During World War II, as seen here, letters written home by Mayville-area servicemen and their photographs were posted in storefront windows for their families and friends to see. (Webb family.)

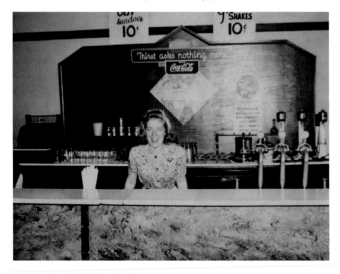

Nadine Henderson Webb
Almost immediately after the Fountainette opened, Nadine's husband, Paul, was drafted. During his absence, Nadine, shown here behind the counter, and her mother-in-law, Blanche Webb, operated the shop together. After serving three years in France and Germany, Paul returned home to a thriving business. (Webb family.)

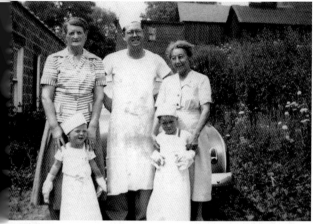

Paul "Spot" Webb and Family
Shown here are, from left to right, (first row) Jim Webb and Paul Webb Jr.; (second row) Blanche Webb, Paul "Spot" Webb, and an unidentified woman. Family ventures have expanded. Currently, Jim and his wife, Sally, own and operate the popular Webb's Captain's Table Restaurant on West Lake Road, managed by their son Ben. Jim and Paul Jr. co-own the adjacent Webb's Candies and Motel, while their brother John maintains the Webb enterprises in Florida. (Webb family.)

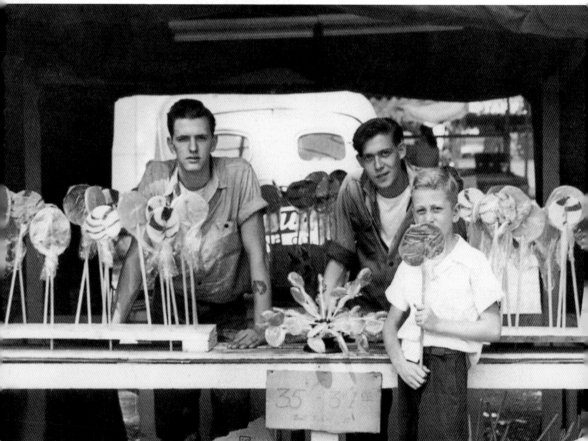

Chautauqua County Fair, 1947
Standing behind the candied wares are Mayville teenagers Edwin Seaton (left) and Rodney "Itch" Nye. They managed the Webb's Candy concession booth at the county fair in Dunkirk, New York. Here, they have sold a giant lollipop to Terry Balcom. Opened in 1946, the Mayville candy factory could produce over 5,000 lollipops daily for local fairs. Webb's signature goat-milk fudge and gift shop souvenirs continue to attract shoppers to their store, which is open year-round. (Webb family.)

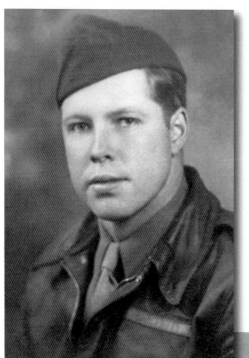

Harold L. Freay

A graduate of Mayville Central School, Freay (1917–2004) served in the US Army Air Corps during World War II and was a POW for 13 months in the Stalag 17B German concentration camp. Returning home, he became a successful businessman, owning and operating a furniture repair shop, an ambulance service, and the Freay Funeral Home, currently managed by second- and third-generation family members. (David Freay.)

Richard Thomas

A 1948 graduate of Mayville Central School, Thomas, an aeronautical engineer, flew fighters in the Air Force prior to his illustrious career at Northrop-Grumman. As chief test pilot of the Tacit Blue aircraft, precursor to the B-2 Stealth Bomber, he flew its first four flights and over 70 of its total 135 flights. Thomas also flew the first flight of the F-5F Freedom Fighter, which established spin recovery procedures. (Cynda Thomas.)

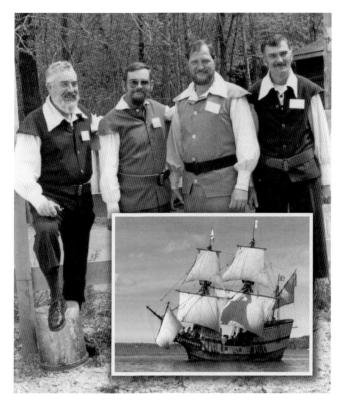

The *Sea Lion*: A Labor of Love

Clad in 16th-century garb, *Sea Lion* crew members and volunteers attend the greatly anticipated launching of the historic sailing vessel on Chautauqua Lake in May 1984. When the ship was commissioned on August 18, 1985, the public was invited to ferry out to the majestic, 63-foot *Sea Lion*, moored off of Mayville's Lakeside Park, for onboard tours. Shown here attending the launch are, from left to right, Stanley Drake, Patrick Foster, Ernest Cowan, and Charlie Smith.

Visiting New England as a young boy, Cowan had been awed by the *Mayflower* replica and dreamed of someday constructing an accurate reproduction of a late-16th-century three-masted, square-rigged English merchant vessel that would actually sail. Years later, his research unearthed a treatise and sketch referred to by diarist Samuel Pepys on the techniques of a 16th-century shipwright. Based on that sketch and obsessed with authenticity, Westfield lumber mill operator Carl "C.E." Lyon, for whom the ship was named, helped locate the requisite virgin white oak on the Cheney farm near Bemus Point. Brothers John and Asa generously donated the wood.

Despite seemingly insurmountable challenges faced by Cowan, his crew, and hundreds of volunteers throughout the 14 years of arduous labor, they persevered, always with the "loving attention of community and media . . . photos . . . snapped at every . . . significant stage [from] the erection of the frame, the unveiling of the figurehead . . . or the move from its land-bound shelter into the mooring bay."

Lacking the financial support to ensure its completion, the Sea Lion Project Ltd. was established in 1979 as a nonprofit organization funded by private donations and foundation grants for the purpose of owning and operating three "floating museums:" the *Sea Lion*, the *Chautauqua Belle*, and the Bemus Point–Stow Ferry. John Cheney, director of vessels, continues to devote much of his time to the operation of the ferry in particular.

Sadly, the dream of Cowan and his crew was short-lived. Too expensive to maintain, the *Sea Lion*, despite overwhelming opposition, was purchased by the Buffalo Maritime Society Inc., only to sink in Buffalo's harbor. Local divers raised it in 2000 and towed it back to Barcelona Harbor. (Jane Currie.)

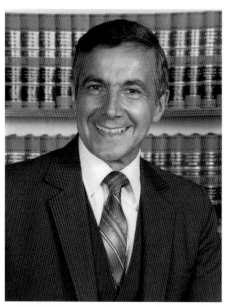

Hon. Joseph Gerace
The Gerace Office Building in the county seat is a tribute to Judge Gerace's stellar political career. He has made innumerable and selfless contributions to his community's well-being, including serving as the first county executive, New York State Supreme Court justice, commissioner of the New York State Department of Agriculture/Markets, cofounder of the People's Law School at Jamestown Community College, consultant for the Robert H. Jackson Center, and the impetus behind the Chautauqua Lake Rowing Association. (Andrea Gerace Magnuson.)

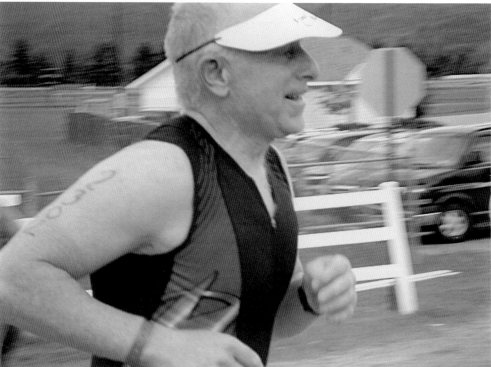

Dr. Robert Berke
Berke, former Chautauqua County public health commissioner, models the importance of a healthy lifestyle as an ironman triathlon participant. For four decades, he has administered medical care to patients in his native Canada, in the United States, and in Cameroon, West Africa. The dedicated family physician has been a crusader for at-risk youth and a pioneer in the use of electronic medical records in his Mayville and Jamestown offices. (Robert Berke, MD.)

CHAPTER THREE

The Lake's Upper East Side

Situated between the incorporated villages of Mayville to the north and Bemus Point to the south, these entities on the northeastern shore of Chautauqua Lake, with no designated borders, seemingly blend together. Access to each is via East Lake Road, Route 430, which parallels the shoreline, as did the Jamestown, Westfield & Northwestern Railroad in earlier years.

Among the earliest families to locate outside of Mayville were the Barnharts and Scofields, whose names were combined to create the hamlet of "Hartfield" on the Chautauqua Lake Inlet. Arriving in the early 1800s, scores of hardy farmers and enterprising shopkeepers created self-sufficient communities, including that of Dewittville, where Filer Sackett settled in 1805. Easily recognized by its four-corner "commercial" hub, Dewittville's best-known landmarks are Camp Onyahsa on Dewittville Bay and the County Home, formerly situated on a 306-acre farm on Meadows Road. From 1832 until 1961, the latter provided comfort and care for the county's "mentally ill, the defective, orphan children [and] the needy aged." Although the home relocated to Dunkirk, New York, in 1961, its adjacent cemetery remains intact.

In 1817, Capt. Anson Leet purchased 106 acres overlooking Dewittville Bay, three miles east of Mayville, which was then bought by the Baptist Union in 1875 for a religious camp. When that venture failed, the newly named Point Chautauqua became a posh resort and, eventually, a residential community among whose accolades is inclusion in the National Register of Historic Places. (The 1881 map on the next page depicts its unique configuration.)

While the above-mentioned communities comprise part of the Town of Chautauqua, Maple Springs, to the south, an insular colony like Point Chautauqua, is in the Town of Ellery, established in 1821. To attract summer visitors during the lake's heydays, the Maple Springs Inn, run by Perry Barnes, its competitor The Whiteside Inn, and numerous boardinghouses lauded their proximity to the steamer dock, trolley station, and post office. Year-round residents continue to appreciate the lake's numerous amenities as well as "the Spring's" relative seclusion.

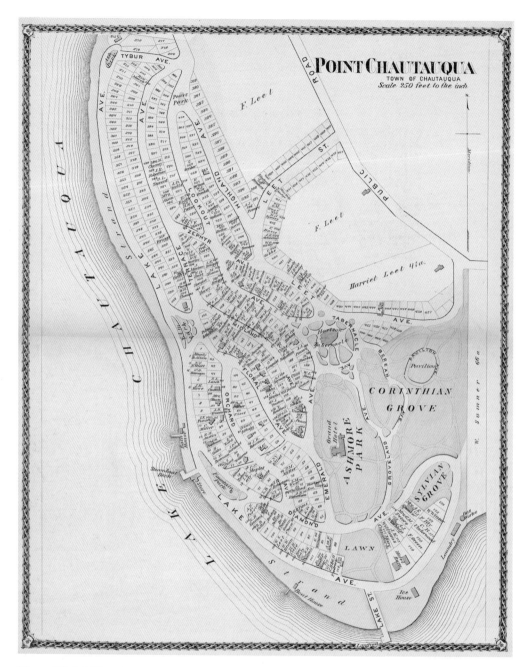

Map of Point Chautauqua

This early map readily illustrates Frederick Law Olmsted's innovative roadway system that paralleled the lake's shoreline. His design optimized the expansive views of Chautauqua Lake for all of the colony's landowners, whether situated on the highest grounds or on lots closer to Lake Avenue. (From *Atlas of Chautauqua County, New York*, 1881.)

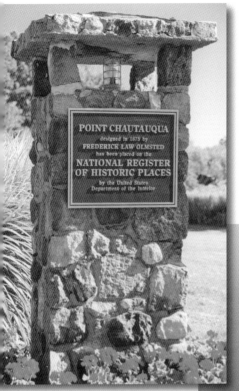

Point Chautauqua Entrance
Point Chautauqua, the one-time religious colony, is located on the eastern shore of the lake. The landmark pillar shown here is situated at the point's entrance on Route 430 near Dewittville. Its entrance on the lakeside was once one of the steamship's busiest docks, from which a regularly scheduled ferry transported passengers back and forth on a triangular route from Point Chautauqua to Mayville to the Chautauqua Institution. (Jane Currie.)

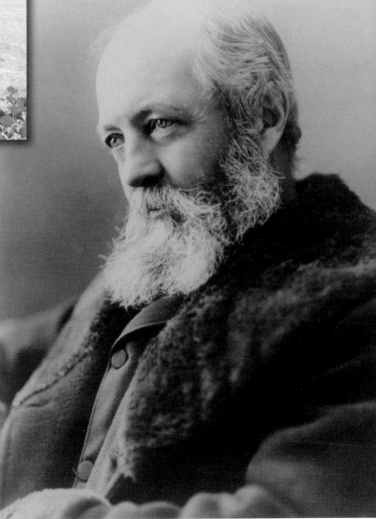

Frederick Law Olmsted
Renowned for his unique layout of the United States Capitol grounds and numerous public parks, landscape artist Olmsted (1822–1903) was commissioned to create a unique design for the Point Chautauqua summer colony. He stressed the importance of space to avoid overcrowding; carriages and pedestrians needed ample room to maneuver gently graded slopes on tree-lined winding roads. Community buildings were for the most part located lakeside, while the residential section occupied higher ground. (The National Park Service, Frederick Law Olmsted National Historic Site.)

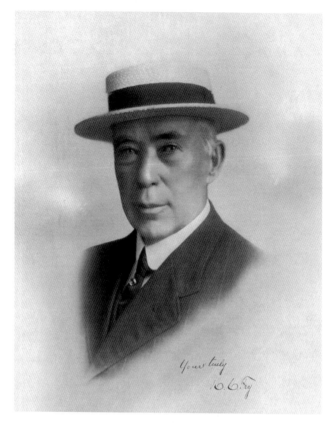

H.C. Fry to the Rescue

In 1875, the Baptist Union developed the desirable tract into a Bible camp across the lake from the Chautauqua Assembly, founded by Methodists the previous year. P.S. Henson, a Chicago minister, proclaimed this newer camp "a national denominational summer resort, where the eye shall revel amid romantic scenery, the brow is fanned by the most delicious and invigorating airs . . . the mind refreshed and refurbished by lectures and essays, sermons and addresses . . . [it] is bound to achieve great success, and be more and more a summer Baptist Mecca, to which tired pilgrims . . . shall rejoicingly resort."

Despite good intentions and grandiose plans, the organizers of this "second Chautauqua" overextended themselves financially, and the second season was poorly attended. In 1876, the property was purchased from the Baptist church stockholders by the Point Chautauqua Association. No longer a religious colony, but advertised as "a place for the pursuit of health and pleasure," its name was changed from Leet's Point to Point Chautauqua. In 1885, when the Point Chautauqua Association charter was overhauled, H.C. Fry (shown here), owner of the H.C. Fry Glass Company in Rochester, Pennsylvania, and the first president of the Duquesne Light Company, purchased the unsold property of the defunct corporation. Catering to a "wealthy and highly desirable" clientele, primarily from Pittsburgh, he and his wife were intent upon the addition of a golf course and swimming pool, among other amenities.

The debonair and civic-minded Fry (1840–1929), a leading stockholder and president of the Point Chautauqua Association, received much press in Jamestown's *Evening Journal* in 1885. "The Grand Hotel [built in 1878 by the Baptist Association] will be refurnished and Chauncey W. Fox will return as its manager. H.C. Fry will bring a select fishing party from Pittsburgh and Buffalo to the Point prior to its June 15 opening for a two-day sojourn." That same summer, "100 Pittsburghers" were guests at the Grand Hotel, and "tumblers [from Fry's glass company] adorn the tables with a . . . picture of the Hotel, which are much admired." (Dr. Edward Davis.)

DeWaldt J. Hicks
In 1921, Hicks, a Mellon family accountant, purchased a stately old home in Point Chautauqua for summer getaways. The Hickses took the train from Pittsburgh to Mayville and then ferried across the lake. In the 1950s, his son "Dee" helped reestablish the Point Chautauqua Association to promote recreation and community activities for all residents. The fourth generation continues to preserve their lakeside sanctuary. (Hicks family.)

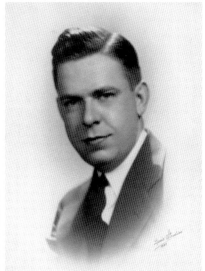

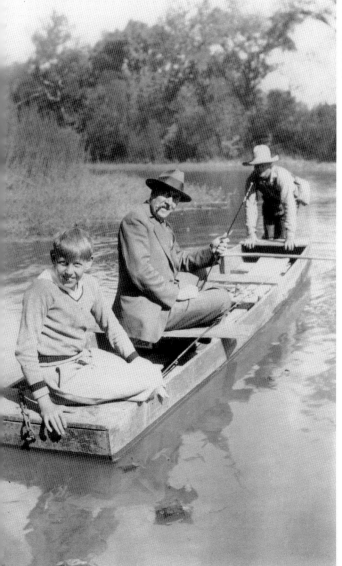

John "Jack" Godlove
Every summer, Dempster W. Godlove drove his family to Point Chautauqua to escape the heat, humidity, and sickness in St. Louis. His son Jack, an insurance agency owner, followed suit, visiting Point Chautauqua for 88 years. The Hespenheides, his mother's family, owned a successful distillery in Pittsburgh and invested in a sprawling summer home. Fishing with grownups was a favorite pastime for young Jack (left). (Godlove family.)

37

Galloway family
Members of the Galloway family pose for a photograph in the 1930s. Shown here are, from left to right, (first row) Grandma Mae and Grandpa Hugh "Bud" Galloway; (second row) sons Harold, Mearl, Vincent, and Laverne. Bud, a former farmer, partnered with George Griffith to operate a gristmill and cider press, which became the landmark Galloway Milling & Supply Company. Brothers Mearl and Vince once operated Parker's general store. In the 1930s, four Galloway families supposedly accounted for 10 percent of Dewittville's entire population. (Galloway family.)

Jessica "Jessie" Galloway Tibbets, 104th Birthday
A graduate of Westfield Academy and Fredonia Normal School, with degrees in musical composition and harmony, Tibbets was pianist and organist for the Dewittville Methodist Church. On her 25th wedding anniversary, one of her published hymns was performed at the Chautauqua Institution's amphitheater during the 1948 worship service. The talented poet was also a newspaper correspondent for both *The Mayville Sentinel* and the Jamestown *Post-Journal*. (Jane Currie.)

Frances K. Holmes

Amazingly agile and alert at 104 years old, Frances K. Holmes (1905–2011), the last of the 79 founding members of the Dewittville Fire Department, proudly rode through the village in the front seat of the fire truck for the organization's 75th anniversary celebration in 2010. The Frances K. Holmes Meeting Room was then dedicated there in her honor. (Jane Currie.)

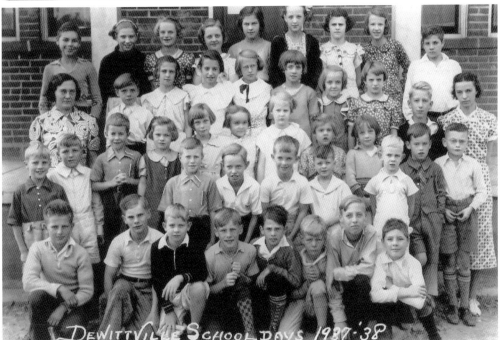

Dewittville School Days

In 1931, Frances Holmes (standing at far right) began teaching grades one through four in the building that later housed the Fire Hall on Route 430. Many of her former students still reside nearby and attended their 50th and 60th class reunions along with their former teacher, whose career in Dewittville and Mayville spanned 37 years. The class shown here is from the 1937–1938 school year. (Betty Holmes Johnson.)

Joseph Sena

Working first in his family's grocery store in Jamestown, Sena (1916–2004) and his wife, Flo, established the Mar-Mar hot dog stand/diner/donut shop in Dewittville in 1952. In the 1960s, the expanded restaurant, which featured rock bands, Italian cuisine, and legendary steaks, became a hot spot for local teenagers. Today, the Mar-Mar Liquor Store on Route 430 is owned and operated by his daughters Mary Margaret Sippel, Jeanne Rice, and Suzanne Hartley. (Sena family.)

Mildred and Charles V. Flagg

Owners of the Flagg Farm on Route 394, the Flaggs, former teachers and conservationists, volunteered at the Jamestown Area Girl Scouts, involved especially with Camps Newatah and Timberlane. They were devoted to the Jamestown Audubon Nature Center, the development of its Burgeson Wildlife Center, and Charles co-founded its photography club. As an agent of the Chautauqua County Agricultural Association and Farm Bureau, he developed improved methods for grape farming. (Peter Flagg.)

Otto Henry Stage, 1946

In the 1920s, Stage, who later married Mildred Curtis, moved to Dewittville as a blacksmith and later became a "traveling smith." Their son Delos, husband of Donna Cheney, built the pilot houses for the Bemus Point–Stow Ferry Bicentennial Celebration in 2011. Grandson Paul received his commercial nautical training at the New York State Maritime College and is the current president of the Sea Lion Project Ltd. (Stage family.)

Jewel Lindell Parker

Grant Parker ran a nearby mill and stoked the furnace for the county poorhouse on Meadows Road, across from his Dewittville homestead. In order to raise money to rebuild the local Methodist church that burned in 1947, his selfless wife, Jewel, mother of five, took cuttings and slips from her garden and traveled door to door as far as Hartfield and Mayville to sell her plants for the project. (Jane Currie.)

41

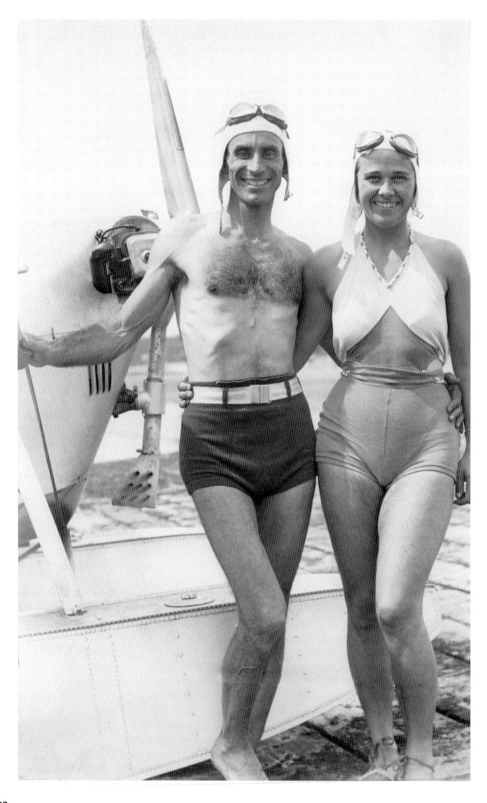

Jonathan "Jon" O'Brian
O'Brian's career as an educator is twofold. In 1992, he joined the faculty of Jamestown Community College, one of his alma maters, and chairs its history department. Since 1987, he has been director of Camp Onyahsa, the Jamestown YMCA camp in Dewittville. A lifelong Onyahsa camper himself, O'Brian is deservedly credited with the camp's overall enhancement. It is now a state-of-the-art, year-round facility featuring innovative programs for all youth and their families. (Jane Currie.)

Spiro Bello
In 1932, a scholarship enabled Bello, an Albanian-American boy from Jamestown, to attend Camp Onyahsa under the tutelage of Roy Wagner, its founder and director from 1924 to 1946. Bello returned there after World War II and, from 1962 until 1982, was the director of both the camp and the Jamestown YMCA. He nurtured campers and initiated the expansion of both the campsite and its unparalleled "character-building" programs. (YMCA, Camp Onyahsa.)

Fred and Gertrude Holbrook Cook (OPPOSITE PAGE)
In the 1800s, Theodore and Jemima Cook settled on Springbrook Road in Dewittville. Prior to his teaching career, their great-grandson Fred taught aviation mechanics in the Navy and became a pilot. While teaching on Long Island, Fred met his future bride, Gertrude, who also obtained her license. As residents of Chautauqua County, Gertrude became chairman of the art department at Southwestern Central School, and Fred taught briefly at Bemus Point High School before becoming a full-time farmer at the Spring Brook Ranch on Bayview Road. He raised purebred Herefords, operated a tree farm, and produced quality maple syrup that was sold worldwide. Their daughter Mary Jane vividly recalls the frequent "fly-in" breakfasts hosted by her parents for fellow pilots who landed on their airstrip. An illustration of their unconventional lifestyle occurred on a wintry day in 1958, when Gertrude found herself stranded in 15-foot-high snowdrifts at the couple's Bemus Point residence. She would not be able to drive the 17 miles to work. Fred came to her rescue. He attached skis to their two-seater Piper Cub and, in only eight minutes, flew Gertrude across the lake to a spot near the Chautauqua Lake Yacht Club. From there, she walked a block and hitched a ride to school. Not surprisingly, Gertrude continued to ride horses until she was 80. (Mary Jane Cook Gerring.)

Ford Cadwell c. 1940

In the 1870s, Charles Cadwell, a Dewittville cheese maker, unknowingly initiated a family tradition. His son Ward (1875–1947), a former baggage master and builder at Point Chautauqua, and his grandson Ford (1904–1996) (pictured), both charter members of the Dewittville Fire Department, operated a 250-acre Holstein dairy farm in the same community until 1947. In the right-hand photograph on the wall, a young Ford (at left) and his helper Cliff Murdock worked together to produce 30-pound cheese wheels daily. (Jane Currie.)

"Colonel" Orlando Haskin Carpenter

In 1869, Carpenter (1845–1915) married Fannie Fenton. In turn, Janie, one of their four daughters, married the above-mentioned cheese maker, Ward Cadwell. No doubt, both of her great-grandfathers would be pleased that Cadwell's Cheese House, the 86-year-old landmark business in Dewittville, has been maintained and expanded by Ford's stepdaughter, coauthor Jane Currie. (Jane Currie.)

Francis L. "Frank" Walsh
From 1953 until 1983, Frank partnered with his brother Martin "Red" Walsh in the operation of Midway Amusement Park, founded in 1898 by the Broadhead family. Frank managed the office, restaurant, and food concessions; booked entertainment; and promoted the park to the general public by advertising its amenities. The park was trumpeted thusly: "Fun for the Entire Family, Lively Entertainment, Rides Galore, Picnic Wonderland, Cozy Family Outings, Excellent Food, Popular Prices." (Frank and Marge Walsh family.)

Maurice "Morey" Charles Bosworth
A lifelong resident of Maple Springs, Morey was its respected historian and the source for its only written history. He was a general contractor, real estate agent, and owner from 1960 through the mid-1980s of the Maple Springs Country Store, where he featured his maple syrup products. When his general store housed the post office, he served as postmaster and was also a charter member of the Maple Springs Fire Department. (Thomas and Sandy McClain.)

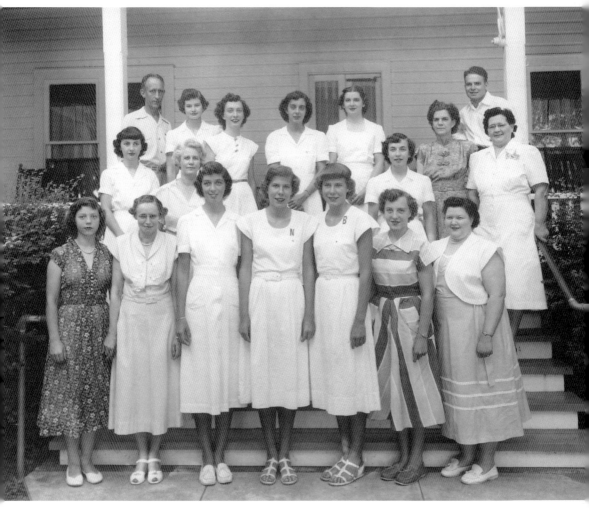

Whiteside Hotel Staff, 1949

Russell H. Haskin (top row, left) and his wife, Mabel (top row, second from right), pose with the hotel's staff. The quaint resort hotel, across the lake from the elegant Athenaeum Hotel at the Chautauqua Institution, was a focal point of Maple Springs, which was easily accessed by rail and steamboat. Its community dock was large enough for a team of horses to drive out, load freight and wardrobe trunks, turn around, and make deliveries to the hotel and other boardinghouses. Russell's mother, Minnie Holman Haskin (1870–1945), a former teacher in Stillwater and Ellery Center, successfully convinced her husband, Ora A. (1866–1944), to trade their farm to William Whiteside in exchange for his hotel. The couple operated it for 35 years. In 1959, "Spike" and Norma Kelderhouse took over its management. (Jean Haskin Raynor.)

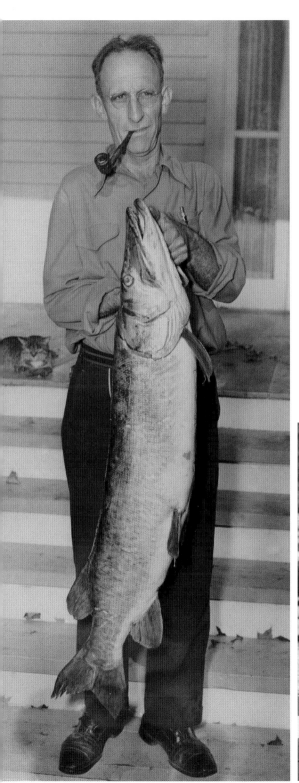

Russell H. Haskin
Following the death of his mother, Minnie, Russell (1902–1984) and his wife, Mabel, operated the Whiteside Inn from 1922 until 1959. He had his own boat livery and, as a fishing guide, enjoyed escorting hotel guests on their fishing ventures. The hotel's dinner menu usually featured his fresh Chautauqua Lake catches. (Jean Haskin Raynor.)

Donald E. "Spike" Kelderhouse
Kelderhouse (1921–2002), an ex–Army Air corpsman, operated a boat rental agency and a charter fishing service. His reputation as one of the lake's eminent muskellunge experts attracted local clientele and fishing aficionados from Peru, Argentina, Australia, and England. The "old salt," who rented ice huts in front of the Whiteside Inn, was also a valued member of the Bemus Point Fire Department and the Sherman Hunting Club. (Jane Currie.)

The Nickersons
Originally from Mayville, Earl and Clara Nickerson and their offspring resided in Maple Springs. Shown here are, from left to right, (first row) Percy, Lee, Royal, Eva Jane, Elwyn, Carol, and Louise; (second row) Ed, Ernie, Elton, Earle, and Lucile. Throughout Chautauqua County, the Nickerson name is synonymous with dairy farming. In the early 1950s, several family members relocated to Wauchula, Florida, where today, great-grandsons Roger and Norm manage nearly 8,000 head of Holsteins. (Nickerson family.)

Tom and Sandy McClain
The retired veterinarian and his wife reside full time in the McClain family homestead, purchased in 1956. To compile a much-needed written *History of Maple Springs* for posterity, the couple painstakingly transcribed the recollections of oral historian Morey Bosworth. They helped implement the 911 system that assigned every "Springs" dwelling a house number for emergency purposes, which then evolved into the publication of the first Maple Springs telephone directory. (Jane Currie.)

CHAPTER FOUR

Bemus Point

William Bemus (1762–1830) purchased several hundred acres of land on both sides of Chautauqua Lake in 1806. Older than the Jamestown settlement, the hamlet that juts out at the lake's narrowest point was named Bemus Point in his honor. Before Jeremiah Griffith settled adjacent to the Asa Cheney farm farther south, Bemus, the first property owner in the Town of Ellery, had already built his log cabin and the area's first sawmill and gristmill.

After the village's incorporation in 1911, the Jamestown *Evening Journal* indicated its importance "as one of the oldest summer resorts on the lake . . . [where] the people are progressive and [make] an effort to make the Point more attractive." In 1913, the Bemus Point Civic Club in concert with village business leaders undertook numerous improvements near the ferry landing, including a new tennis court, bathhouse, refreshment stand, commodious pavilion, and baseball diamond. The Civic Club was "one of the liveliest organizations of the vicinity . . . a great influence for good in Bemus Point," and in 1916, it was "quite evident that [their members] propose to extend their influence even into the Chautauqua Lake Association." Other projects were undertaken by the Bemus Point Community Club. Organized in 1926, the club's members included the civic-minded Lenhart, Johnston, Ward, Cheney, Skillman, and Lord families.

By 1920, Bemus Point, located midway between Mayville and Jamestown, with a steamboat dock, trolley station, and ferry landing, became a bustling summer resort. Tourism was its only industry. According to the 1920 federal census, there were 227 residents. There were only about 100 more in 2000 in the three-square-mile village. Its family-friendly ambiance adds to its charm.

In 2005, the Bemus Point Historical Society placed a marker on the lawn of the Hotel Lenhart, commemorating the four lakefront hotels that from 1871 to 1880 were located on Lakeside Drive between Main Street and the village park. Visitors still stroll back and forth from the eastern terminus of the Bemus Point–Stow ferry adjacent to the Village Casino, to restaurants and boutiques in the village center—a welcome sight in the good old summertime.

The Lenhart Family

Charlotte Lenhart sits in the front row between her parents, Dr. John Jordan "J.J." Lenhart and Isadora "Dora" Baldwin. The women behind them are unidentified. In 1881, the prominent physician with a large practice in Bemus Point and its surroundings built the Hotel Lenhart at the corner of Oak (later Lenhart) Avenue and Lakeside Drive, its current site. Despite two costly fires, the hotel emerged from the ashes and, incredibly, celebrated its 130th anniversary in 2010. While Dr. Lenhart tended to his patients, Dora, daughter Charlotte, and her husband, George Johnston, handily managed the hotel.

Few might know that, at one time, Charlotte seriously entertained the idea of purchasing more property in the village. In a March 20, 1912, letter to George, she informed him that "Mr. Broadhead has had men here making calculations and is simply biding his time to absorb Bemus Point." She told George of the upcoming sheriff's sale on May 15. "Would you consider this real estate proposition? . . . something of a speculation but land is land . . . it includes the little restaurant . . . by the boatlanding and the waterfront extends from Pickards to John O. Johnston . . . the empty corner across from the Pickard House, the dwelling house next to it . . . and the business which contains the post office. . . . It is the main business corner of Bemus Point."

For whatever reason, the Johnstons did not acquire that particular property, but generations of guests continue to be treated to the Hotel Lenhart's old-world ambiance and amenities. Plaques on several of the signature rockers evoke memories of special guests who chose to spend their summer dining, enjoying spectacular sunsets from the wide, wrapping veranda, and listening to Frank Sinatra tunes in the Lamplighter Lounge.

After Dora's death in 1934, Charlotte enlisted the support of her sons George Jr. and John Lenhart to manage the hotel. For years, John's wife, Jane, ran the kitchen. The ever-popular hotel is currently owned and managed by fourth-generation Johnston family members Barbara Jane "Bebe" Johnston, her brother John Jr., and his wife, Debbie. (Johnston family.)

George Anson Johnston
Following their lengthy correspondence courtship, Johnston (1867–1939) married Charlotte Lucille Lenhart in 1912. The traveling salesman for the Henry Wilhelm Glue Company of Pittsburgh gladly abandoned the "tramp business" for Charlotte, his adored "Lady of the Lake," and joined her and his in-laws in the operation of the Hotel Lenhart. (Johnston family.)

Charlotte Lenhart Johnston
Charlotte (1887–1968), a graduate of the Hill Piano School in Jamestown, spent leisure time sharing her talents with Jamestown's Mozart Club and DAR chapter; Bemus Point's Study Club and Civic Club, of which she was a charter member; and Chautauqua County's Society of Artists. Several watercolor paintings and drawings by "the pianist, the artist and the 'Grand Dame' of the Lenhart" are displayed in the hotel's sunroom. (Johnston family.)

Velona Stone Rappole
"One of the best loved and widely known women" in Bemus Point, Rappole (1861–1938) was a respected pioneer in the Chautauqua County hostelry business. In 1893, she and her husband, "A.W.," built and operated the 45-room Columbian Inn. Following her husband's death, Velona retained her tavern-keeper status as proprietor of the Columbian and the Hare 'n' Hounds Inn. The keen businesswoman helped found the Bemus Point Study and Civic Clubs. (Rosemary Rappole.)

Albertus Whitney "A.W." Rappole
Two generations of Rappoles greatly contributed to the hotel and tourism industries on Chautauqua Lake. The Rappole Allotment, purchased by "A.W." (1852–1908), included "much of the waterfront, the lot across from the village park, the ferry landing, the property that became the golf course, a working farm four miles north around Bemus Bay, and the lot where the Columbian Inn was built." He generously deeded much of this to his village. (Rosemary Rappole.)

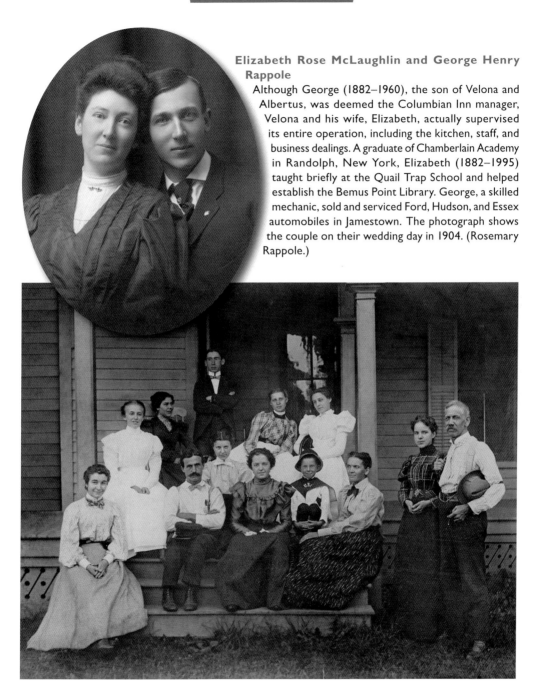

Elizabeth Rose McLaughlin and George Henry Rappole

Although George (1882–1960), the son of Velona and Albertus, was deemed the Columbian Inn manager, Velona and his wife, Elizabeth, actually supervised its entire operation, including the kitchen, staff, and business dealings. A graduate of Chamberlain Academy in Randolph, New York, Elizabeth (1882–1995) taught briefly at the Quail Trap School and helped establish the Bemus Point Library. George, a skilled mechanic, sold and serviced Ford, Hudson, and Essex automobiles in Jamestown. The photograph shows the couple on their wedding day in 1904. (Rosemary Rappole.)

Columbian Inn Staff and Owners

Shown here in 1898 are, in unknown order, Will Haskins, John Augustine, Ferris Deniston, Sophia Goldberg, Caroline Goldberg, Mabel Stone, Arlie Waite, Sadie Thompson, Margaret Yarr (?), Macy Bulluck, M. Grace Towers, A.W. Rappole, and Velona Rappole. Located across from the steamboat dock, the inn, named in honor of Chicago's 1893 World's Columbian Exposition, was a popular destination. After World War I, the Rappoles bought the adjacent Pickard House and operated the consolidated hostelries as the Bemus Point Hotel. (Kathleen Sullivan Crocker.)

Mattie Barrett and Hiram B. Sullivan, 1899
Following her "School Marm Days," Mattie helped found the Bemus Point Library and Study Club and, with Dora Lenhart, organized the Civic Club, which worked with the village board on many projects. The Mayville native's articles in the *Westfield Republican* and for the Chautauqua County Historical Society, written while a member of the Patterson chapter of the DAR in Westfield, are a source of inspiration and pride for her granddaughter, coauthor Crocker. (Kathleen Sullivan Crocker.)

HOTEL PICKARD ON CHAUTAUQUA LAKE

H. B. SULLIVAN, Proprietor BEMUS POINT, NEW YORK

Opens May 28, 1919

Mr. Sullivan courteously solicits your patronage.

Table D'Hote dinner 6-8 p. m. Special attention given
Cuisine unexcelled Banquets, Private Suppers
Ask for rates Auto Parties

Hotel Pickard Business Card, 1919
After his marriage to Mattie in 1896, Hiram B. Sullivan left his Hartfield grocery and meat market to open Sullivan and Barrett Grocers in Bemus Point with his brother-in-law Albert Barrett. He operated the Hotel Pickard from 1917 until 1919, when the family moved into the Portage Inn in Westfield. After Hiram's death in 1931, Mattie and her son James, coauthor Crocker's father, continued its operation until 1938. (Kathleen Sullivan Crocker.)

Edith Bates and John Calvin Cheney

Although the original Cheney clan settled between Ashville and Stow in the Town of Harmony (known today as Cheney's Point), Jonathan, an early ancestor, recognized the quality cherry, maple, and other hardwoods on the lake's opposite shore. Thus, in 1806, he relocated to the lake's east side to purchase 1,000 acres of valuable timberland, which he eventually divided among his children. At its most expansive, the Cheney farm stretched from Greenhurst Creek to south of Bemus Point.

In 1850, the marriage of Catherine Griffith and Asa Cheney (1826–1906) united two prominent Ellery families. Asa was highly respected for "his indefatigable industry, intelligence and knowledge of agricultural methods." After graduating from the Eastman Business School in Poughkeepsie, New York, in 1895, John Calvin, their 11th and youngest child, returned home to the family farm. After his marriage to Edith Bates in 1900, the couple worked side by side with relatives to operate their 140-acre Belleview farm, "one of the finest on the main road between Bemus Point and Jamestown," with "one of the most beautiful views of the lake."

While Asa had been a grain and dairy farmer, John Calvin concerned himself with conservation methods and became a pioneer in the development of farming and agricultural agencies. He worked in tandem with the Grange League Federation (GLF) and Agway and was a 48-year member of the Union Grange in Jamestown. Calvin was also a charter member of the Dairymen's League and a director of the Farm Bureau office in Jamestown, which was operated by farmers for farmers and emphasized legislation to maintain agricultural economic stability.

Like her mother-in-law, Catherine Griffith Cheney, Edith was "abreast of her times." They were both active in the women's suffrage movement as members of the Fluvanna Political Equality Club and were members of the Union Grange. While Catherine was devoted to the Chautauqua County Historical Society, Edith's passion was politics, specifically, the Republican Party.

Today, yet another generation of Cheneys, also named Asa and John, continues the family's legacy and invaluable contributions to Chautauqua County. (John Cheney family.)

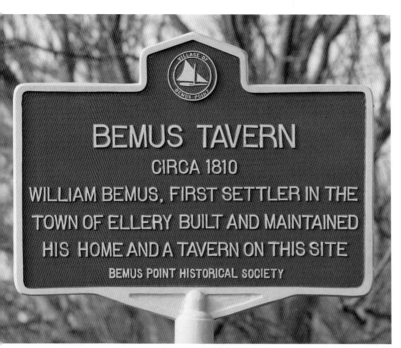

Bemus Tavern
The Bemus Tavern, as this historical marker notes, was one of the oldest taverns in the Town of Ellery. Its location, a mile outside the village on the bank of Bemus Creek, provided sufficient room to house the sleighs, wagons, carts, and carriages of the tavern's guests. (Jane Currie.)

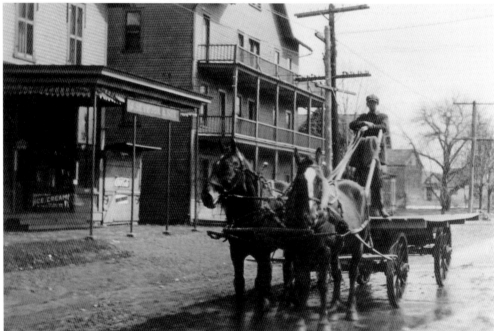

Walter Shepardson
At age 30, Shepardson (1861–1948) purchased property in Ellery, and the successful farmer would come to be hailed for his "model farm." Like the neighboring Cheney family members, Shepardson belonged to the Union Grange and devoted himself to the promotion of agricultural development in Chautauqua County. The old Shepardson farm on Westman Road was once the site of the Bemus Tavern. Shepardson is shown here in 1916, with the Hotel Rappole in the background. (Shepardson family.)

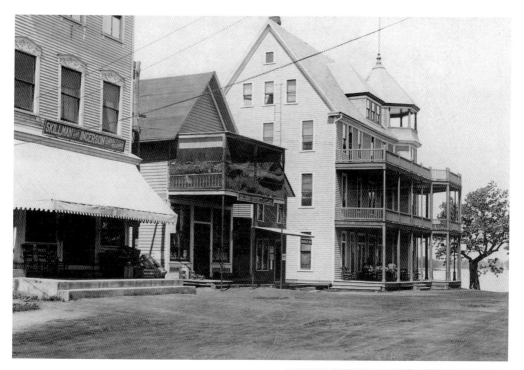

Main Street in Bemus Point
Establishments on the south side of Main Street in 1917 are, from left to right, Skillman and Ingerson in the Odd Fellows Building, Sullivan and Barrett Grocers, and the Hotel Pickard. Established in 1906, Skillman's, the only remaining business of the three, was owned by various family members and one-time partner Don Wight. Its stock of merchandise has changed, from fishing equipment and household and outdoor goods to upscale clothing and gifts, sold by third-generation owner Carol Skillman and her husband, Lonny Clark. (Kathleen Sullivan Crocker.)

Norman Cheney Skillman
Bemus Point native Skillman (1927–2009) was simultaneously a village merchant, an avid fisherman and hunter, and a member of the Nature Conservancy and the New York Forest Association. He and his wife, Helen, planted thousands of trees in their own backyard, making it a "virtual arboretum" and wildlife refuge while also beautifying their village center. Following Skillman's funeral service at Camp Onyahsa, "Plant a Tree" magnets were distributed to family and friends. (David Dibble.)

Elizabeth Blanchard Bemus
Following her marriage to Charles W. Bemus, great-grandson of William Bemus, Elizabeth (1849–1933) moved from Mayville to Bemus Heights. For nearly 30 years, she served as the librarian at Bemus Point Library, an organization she helped found and to which she donated land on Center Street. For many years, she actively served her community as both president of the Bemus Point Study Club and Sunday school superintendent of the Methodist Episcopal church. (Bemus Point Library.)

Mary Jane Carlson Stahley
A lifelong resident of Bemus Point, Stahley resides on the same property her great-great grandfather Ezra Felton purchased from the Holland Land Company around 1850. The widow of former mayor and firefighter Robert E. Stahley, she served as the village's librarian for 25 years and continues in the role of historian of the Bemus Point Historical Society. She generously shares her abundant knowledge of the entire Chautauqua Lake region with others. (Pamela Berndt Arnold.)

James N. Selden

Selden, a Pittsburgh financier and chemical magnate, purchased 15 acres of land across from the Bemus Point golf course from the Rappole family for his sumptuous estate. In 1930, he built the casino pavilion, but died before he could fulfill his plan of replacing the former Pickard House. Once a retreat for the Catholic Diocese of Buffalo, his Bemus Point landmark estate is being restored to its original grandeur by its new owners. (Selden families.)

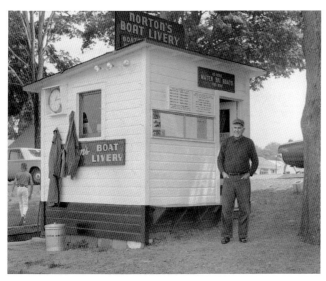

The Norton Family

Capt. Caleb Norton settled in Bemus Point around 1850. Descendants Victor Norton Sr. (seen here standing in front of Norton's Boats and Cottages) and Victor Norton Jr. were also passionate about Chautauqua Lake. Now both deceased, father and son researched, amassed, and preserved priceless collections of steamboat, trolley, and hotel memorabilia relating to the heydays of the lake. Historians have derived great benefit from their labors. (Bruce Norton.)

Lawson Family Legacy

David S. Lawson Sr. (1886–1971) purchased property at 73 Lakeside Drive, which was once the site of a garage for horseless carriages on the street level and a repair shop with docking facilities below. Since its founding in 1918, the former Lawson Boat and Engine Company, later renamed L-S Aero Marine, has been synonymous with affordable, quality family boating on Chautauqua Lake. Working through the 1930s, David and his wife, Margaret (1896–1985), a former teacher in Ellery and Jamestown, managed the operation and oversaw all of the servicing, storing, building, and selling of boats at their "nautical country store."

When their oldest child, Jean, a 1950 graduate of Cornell University's School of Journalism and Floriculture, returned to Bemus Point after a successful career in New York City as garden editor of *House Beautiful*, she, like her mother, devoted herself to all aspects of the growing operation. After Margaret's death, Jean became the sole bookkeeper as well. For 45 years, she managed the Bemus Point store with her younger brother, David Jr. (seen here).

David was Bemus Point Central School's class of 1951 valedictorian, yearbook editor, and basketball team captain. After graduating from the Webb Institute in Glen Cove, New York, where he attained degrees in naval architecture and marine engineering, he spent three years on active Naval duty before returning to the lake he had grown up with and loved. His knowledge and expertise have been a welcome addition to both the chandlery and its satellite shop on the outlet near Fluvanna.

In 2010, David donated the Lakeside Drive property to a group of businessmen, who, along with Lawson, founded the Lawson Boating Heritage Center on Chautauqua Lake to preserve, display, and highlight as much of the lake's boating history as possible. Dedicated on May 19, 2012, its state-of-the-art showroom and workshop are specifically designed to present exhibits, photographs, artifacts, and hands-on displays of the lake's rich boating heritage and to teach the traditions and skills of the past with respect to wooden-boat building and restoration. (Jane Currie.)

CHAPTER FIVE

The Lake's Lower East Side

Griffith's Point (renamed Sheldon Hall), Greenhurst, and Fluvanna are hamlets between Bemus Point and Jamestown in the Town of Ellicott. Both the Griffith and Strunk families are deeply rooted there; descendants of their intermarriages included members of the Jonas Simmons family and descendants of Asa and John Cheney. Between the 15 children brought by the Simmons family and John Strunk's four children, "a whole school district came in one company."

Jeremiah Griffith (1758–1842) and his family left Rensselaer County for Ohio, but heeded the advice of fellow traveler William Bemus, the first area settler who, like Griffith, realized the importance of staking claim to property previously cultivated by Native Americans. In 1806, the second settlement in the Town of Ellery was about five miles from the future site of Jamestown. Jeremiah and his son Samuel built log cabins, cleared the land at a time when "not a blow of an axe had been struck between that site and Warren, Pennsylvania," and, working with the Bemuses, cut the lone road from Bemus Point to Jamestown. By 1889, the Griffith family was the largest in the county.

Greenhurst, situated between Griffith's Point and Fluvanna, was the site of a popular swanky hotel with its own steamboat landing. It was named for former Jamestown mayor Eleazer Green, who is credited with the reclamation of swampy lands on his property and the establishment of a fish hatchery.

Jeremiah Griffith also aided Fluvanna's development by building a log schoolhouse on his property while farmers Seth and Samuel built a gristmill. Blacksmiths, wagon makers, coopers, shoemakers, tanners, and tailors set up shops in the small community, as did potter Jacob Fenton. In 1814, he had established a pottery in Jamestown near today's Potter's Alley and moved the operation to Fluvanna three years later. After his death in 1822, his son William managed his father's business and was joined in 1826 by the newly arrived and experienced potter Samuel Whittermore, Fluvanna's first postmaster, temperance society founder, and hotel owner. Together, the two men manufactured crocks, milk pans, cups, and similar items, to be peddled in exchange for goods and services.

Greenhurst Hotel
In 1889, Jamestown attorney Eleazer Green built this elaborate lakefront hotel. A brochure touted its amenities: "within easy rowing distance of Lakewood; 30 acres of groves, tennis grounds, drives and cottage lots; thousand feet of lake beach; house, private boat houses, and the state fish hatchery. Promenade pier extending 500 feet into the lake; livery stable." The hotel burned down in 1931. (Mary Jane Stahley.)

SHELDON HALL, CHAUTAUQUA LAKE, N.Y.

Sheldon Hall
Griffith's Point, the first steamboat stop past Jamestown, was named for Jeremiah Griffith, builder of the Griffith's Point Hotel. It was renamed Sheldon Hall when Porter Sheldon, a Jamestown attorney and a pioneer in the photographic paper industry, purchased 52 acres for his summer residence plus accommodations for guests. His mansion was closed in 1920, razed, and replaced with the secluded summer retreat of his son Ralph C. Sheldon. (Kathleen Crocker.)

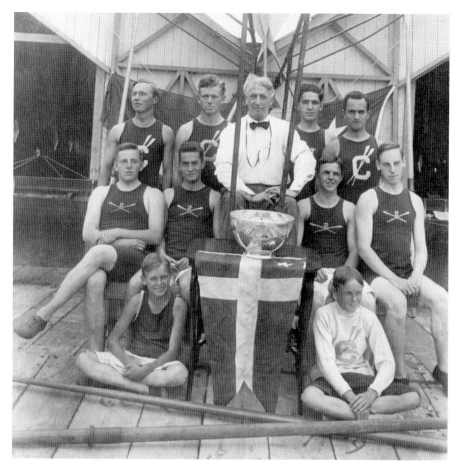

Chadakoin Crew Club

From about 1895 to 1917, rowing took precedence over sailing as a popular sport at colleges and universities. Like Jamestown's William Broadhead, a member of the Yale University crew, athletes needed to practice back home during the summer months to maintain their strength, endurance, and stamina. As a result, those students formed the nucleus of local crews such as the Chadakoin Rowing Club, founded in 1894 at the lower end of Chautauqua Lake, adjacent to the Greenhurst Hotel, which stored its racing shells and served as its social center.

When the hotel closed in 1908, the club purchased a prime piece of land across the lake in front of the Lakewood Country Club at the foot of Chautauqua Avenue. The club established its second clubhouse and boathouse at this location. In 1930, it built yet another boathouse, at the foot of New York and Lakeview Avenues. This, in 1937, became the Chautauqua Lake Yacht Club.

Not only did the club compete with the Chautauqua Crew Club, located on the Chautauqua Institution's waterfront, but it also hosted crews from Spain, Portugal, Brazil, and Newfoundland during the world-class International Snipe Championships in 1946. Although formal crew racing was nearly non-existent, clubs promoted yacht racing and aquatic sports for amateur sailors.

Recognizing the merits of reviving the sport on the lake for high school, collegiate, and adult rowers, the Honorable Joseph Gerace recruited proficient oarsmen Kevin S. Sixbey, Lee Stein, Stephen E. Odrzywolski, and Eric A. Larson to help establish the Chautauqua Lake Rowing Association in 2005. Every year since then, over 200 individuals have received instruction in a variety of programs, ranging from competitive to recreational to fitness rowing. The CLRA is headquartered at its McCrea Point boathouse, near the Jamestown boat landing, the once-bustling steamboat terminus. (Mary Jane Stahley.)

> Mrs Sarah M. Bentley
> Fluvanna - Chautauqua Co, - N.Y.
>
> This book is presented you
> because of your contribution - in 1900 -
> to the proposed "Standing Fund" - and its
> cheerful transfer to the printing of this book -
>
> very sincerely yours
>
> Susan B. Anthony
> 17 Madison Street
> Rochester - N.Y.
>
> 1820 - Feb 15 - 1903

Susan B. Anthony Inscription

In 1891, the Fluvanna Political Equality Club held its first meeting in the home of vice president Sarah Bentley to discuss the status of women and children. This extant inscription in *The History of Woman Suffrage* (volume IV, 1902) attests to the personal connection of Sarah Bentley, a charter member, to the esteemed crusader Susan B. Anthony. (Fluvanna Free Library.)

"Miss" Ophelia Griffith

In 1889, the Griffith family was the largest in the county. Ophelia (1837–1920, seen here) and her sister Martha operated a boardinghouse and farm at Martha's Vineyard, near their sister Catherine and brother-in-law Asa Cheney's farm. In 1906, the spinsters greeted 200 other descendants of Jeremiah Griffith, who arrived at their home by boat, train, and carriage to celebrate the family's 100th anniversary in Chautauqua County. (Kimberly Peterson Bentley.)

Fluvanna Political Equality Club

Chautauqua County women were among those involved in the grassroots support for the national movement of women's suffrage in the late 1800s. According to Traci Langworthy, assistant professor of history at Jamestown Community College, "our [Chautauqua] county was home to some of the earliest of these clubs in the country. Local women, working in concert with state and national organizers, helped to challenge old convictions about women's supposed limitations and disinterest in political matters."

Officers of the Fluvanna Political Equality Club, organized in 1891, were Hetty Sherwin, president; Sarah Williams Bentley, first vice president; Minnie Strunk Cheney, second vice president; and Mattie L.V. Young, secretary/treasurer. In 1962, historian Bertha M. Larson noted, "The women of Fluvanna responded to the cry of equality for women and delved into the political field as virulent a pioneer spirit as the State of New York could boast." Other members of this "banner club" listed in extant study club notebooks include Anna B. Scofield, Estelle Smiley, Jeanette Bentley, Harriet and Kate Cheney, Ida Griffith, Edna Mecusker, Adelia and Jesse Strunk, and, shown from left to right in the photograph, Eleanore Grant, Miss Ophelia Griffith, Sarah Dickenson, and Hettie Shaw.

Ardent supporters of temperance and women's rights, they attended rallies of suffragette leaders held at the Chautauqua Assembly or elsewhere in the county. In 1888, Susan B. Anthony and Elizabeth Cady Stanton gave an inspirational address at Allen's Opera House in Jamestown, and in 1913, club members traveled to Mayville to hear featured speaker Carrie Catt Chapman, who had contacted Hetty Sherwin in advance to urge all local political clubs to attend the annual Chautauqua County woman suffrage convention and to participate in the upcoming Suffrage Rally Day.

Following the passage of the 19th Amendment, the club was renamed the Fluvanna Study Club and, like the Bemus Point Study Club and the Tuesday Club of Mayville, members founded their local library and joined the Western New York Federation of Women's Clubs, which fostered an emphasis on lifelong learning, cultural activities, and community service projects. (Kimberly Peterson Bentley.)

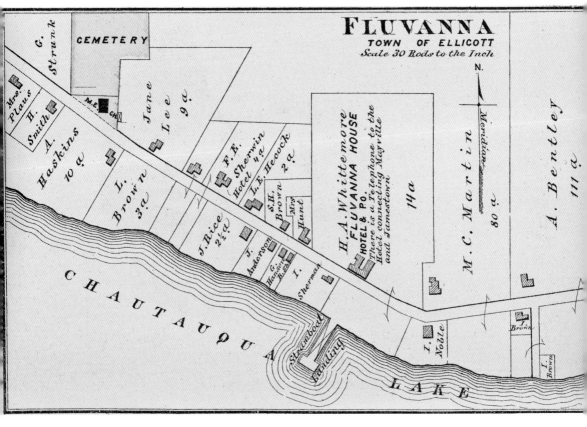

Map of Fluvanna Farms, 1881

Sarah Bentley's son Gustavus (1891–1964), great-grandson of Uriah Bentley, who founded Lakewood in 1810, was born on the Bentley family farm in Fluvanna. Gustavus enjoyed an illustrious career as an educator, historian, and conservationist. He served as principal of Washington Junior High School in Jamestown for 25 years, was president of the Chautauqua County Historical Society, director of the YMCA, and an active member of Little Theater. His major legacy, however, is the Bentley Sanctuary, a 47-acre preserve developed on his property, which, since 1960, has been operated by the Jamestown chapter of the Audubon Nature Center. O. Gilbert Burgeson, the chapter's founder, initiated an annual Mother's Day Walk on its trails to view over 53 species of flowering plants and over 70 species of birds, surveyed there by Roger Tory Peterson in 1933. It remains a popular spring event.

The Whittermore family has a rich history as well. In 1836, Samuel Whittermore (1799–1875) built the Temperance House, with over 200 feet of lakefront footage close to the steamboat dock. Called the Whittermore Hotel and then the Fluvanna House, it is considered Chautauqua Lake's first summer resort. Following his father's death, Henry Whittermore operated it until Carl W. Scofield of Jamestown, who made his fortune in the oil business, bought it for his residence in 1888 and renamed it the Bungalow.

On the map, note also the adjacent Sherwin House, built in 1871 by Philo Sherwin; the Mahlon C. Martin property, part of which is the current site of the War Veterans Recreation Inc.; and the Strunk and Bentley family farms. (From *Atlas of Chautauqua County, New York*, 1881.)

Mahlon C. Martin

Martin, a wealthy New Jersey industrialist, and his sisters Serena, Eliza, and Maria, summered at the Temperance House in Fluvanna. In 1870, Martin bought the adjoining farm from Alexander Simmons for their summer residence.

According to local folklore, during one of their hotel visits, one sister ordered a second piece of berry pie; when her request was denied by proprietor Whittermore, an angry Mahlon Martin sought revenge. In 1894, Martin bought the place, "cut" the property into three "pie-shaped" pieces, and "repositioned" them. The former hotel's east wing was moved to the present site of the Fountain Bowl on Route 430 as a dwelling, the west wing was moved back for a sheep barn, and the original hotel was relocated to the western part of the property for tenant uses.

Of Martin's nearly 400 acres in and around Fluvanna, extending from the lakefront to Townline Road and from Interstate 86 to Strunk Road, he transformed an eight-acre tract into a complete working farm with horses, cattle, and livestock. Accessed by several entrances and crisscrossed by multiple roads and lanes with colorful names, the estate was the perfect setting for the pretentious horse stable and carriage barn resembling a medieval castle. No expenses were spared in its construction, elements of which included imported pink mortar, fireproofing, and a steam heating system. Unfortunately, Martin died before constructing an even more magnificent personal residence. Following his death and that of his siblings, his nephew Mahlon C. Martin Jr. of Foxburg, Pennsylvania, became the beneficiary and, in 1922, sold the remainder to Charles Lindbeck and Magnus Anderson of Jamestown.

The War Veterans Recreation Inc., celebrating its 70th anniversary in 2013, purchased "Bittersweet," part of the Martin estate, from the Bank of Jamestown and the estate of William M. Maddox. Since 1945, the impressive structure has been the home of the War Vets, a unique center for returning troops. The 1,200-member organization sponsors community endeavors, including the Ellery recreation program and baseball team, and the annual Motorcycle Run for Hospice. (War Vets Recreation Inc.)

Allen E. Peterson

In 1964, the Albert Nelson and Everth Peterson properties merged into one farm on Strunk Road. Established in 1955 as a roadside market, the legendary Peterson Farms on East Lake Road has employed generations of nearby residents in its market and fields. Peterson, who raises Polled Hereford cattle and Austrian Haflinger draft horses, has served on the Chautauqua County Fair Board, the county's soil and water board, and the Cornell Cooperative Extension. (Jane Currie.)

William Hendrick Strunk

In 1817, William Strunk and his parents, Jacob and Elizabeth, relocated from Renssaelaer County to a farm three miles northwest of Jamestown in the Town of Ellery. In 1834, he married Jane Van Vleck; two of their ten children, Isabella "Belle" and Catherine "Kate," married Cowing brothers from the nearby Town of Busti. Strunk (1807–1878), like other family members, was an enterprising and prosperous farmer and stock raiser devoted to the land. (Carol Fox Shephard.)

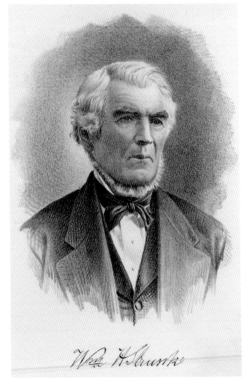

CHAPTER SIX

Jamestown

Located in the Town of Ellicott, Jamestown, the third settlement of importance around the lake, was founded by James Prendergast (1764–1846), one of the members of the "emigrant train" previously mentioned. Awed by the potential of the waterpower and hills covered with hardwood forests, he envisioned mills, factories, and a transportation route conducive to the establishment of a lumbering and milling village. In 1809, James's brother Martin Prendergast bought 1,000 acres of land and deeded them back to James who, in turn, purchased additional property. In 1811, James and his wife settled into their log cabin on the banks of the Chadakoin River at "the Rapids," so named because of the swift currents at the outlet of Chautauqua Lake, and later renamed Jamestown for its founder.

By 1813, in addition to lumbering, pioneer businesses included a pottery, blacksmith shop, tannery, shoemaker, and tavern. Brothers Jediah and Martin Prendergast opened a branch of their Mayville general store. Village industries engendered rapid growth, and Jamestown soon became a manufacturing town with hardworking industrial entrepreneurs. At one time, Jamestown companies produced 60 or more products that were shipped throughout the country and abroad.

In 1860, the advent of the Atlantic & Great Western Railroad, part of the extensive Erie Railroad system, further spurred Jamestown's commercial, industrial, and economic development. The commitment and vision of the Broadhead family of Jamestown, with its steamboat and railway companies and trolley parks, similarly opened the entire Chautauqua Lake region to tourism.

The village was incorporated as a city in 1886, the largest in the county. According to Jamestown historian B. Dolores Thompson, by 1900, Jamestown had also become the county's undisputed industrial center, due primarily to its wood furniture, worsted fabric, light metal products, and photographic paper industries. One of every four of the town's 25,000 residents was employed by a local factory. Its economic stability attracted people of varied ethnic groups to the region, and these diverse cultures formed the fabric of Jamestown's educational, religious, and social life.

Gov. Reuben Eaton Fenton

"A wise . . . incorruptible and patriotic statesman," Fenton (1819–1885) served as a US senator and, from 1865 until 1869, as governor of New York. Nicknamed "the Soldiers' Friend," he helped pass the Soldiers' Pension Bill, which provided financial support for those disabled in the line of duty. Once the national headquarters of the Grand Army of the Republic, the Fenton Mansion in Jamestown is listed in the National Register of Historic Places. (*Post-Journal.*)

Josephine Fenton Gifford

In 1879, Governor Fenton's daughter Josephine, the wife of banker Frank Gifford, established the Mozart Club and served as its president for 40 years. The women's cultural organization was created to further the talents of its members while inspiring a deeper appreciation for music in others. Coveted scholarships for music study at the Chautauqua Institution and various prizes have been awarded to area students for their musical accomplishments. (*Post-Journal.*)

Elizabeth Warner Marvin

In 1889, Jamestown socialite Elizabeth Warner (1866–1950) married the successful Robert N. Marvin. She bequeathed her elegant West Fifth Street mansion and its furnishings to the women of Jamestown "to provide a meeting place for societies of moral or mental improvement of women engaged in literature, musical, educational, patriotic, scientific or historical work." The treasured Community House remains vital to numerous women's organizations in the city today. (*Post-Journal.*)

Betty Weakland Bixby

At the age of four, Weakland, the extraordinarily gifted and poised orator and child evangelist, began sharing circuit pulpits with her Baptist minister father. She captivated large audiences with her singing and quotation of scripture. The original tabernacle built in Jamestown to accommodate her converts was quickly outgrown, and the permanent Weakland Chapel was built at 25 Camp Street near Allen Park. (Bonnie S. Anderson.)

The Goranson Family
Shown here are, from left to right, (first row)
Ebba H. Goranson and Niles Goranson; (second
row) Arthur G. Goranson and Julia Jacobson
Goranson. Julia and Niles were longtime members
of the Swedish Zion Church, where Niles was the
organist and choir director. Not surprisingly, their
children became "co-architects" of exceptional
choral and orchestral music programs in the
Jamestown schools. Ebba founded the A'Cappella
Choir, and Arthur, the school's music director from
1924 to 1948, founded the New York State Music
Association. (Dorothy Johnson McCall.)

Red Raider Marching Band
Jamestown High School's entire music department
possesses an enviable reputation. The marching
band program was developed by Arthur Goranson.
Under the directorship of Lou Deppas, the band
competed locally and nationally from 1982 until
2000, as the wall of Strider Field indicates. The
A'Cappella Choir, directed by Donald B. Bube, Brian
A. Bogey, and Norman D. Lydell, has performed
concert tours in the United States and abroad.
(Jane Currie.)

HOME OF THE "RED RAIDER" MARCHING BAND

NYSFBC STATE CHAMPIONS
1991 CLASS AAA
2002 CLASS LS2

NY REPRESENTATIVE IN MACY'S THANKSGIVING DAY PARADE
NEW YORK, NEW YORK
1984, 1989, 1995

NY REPRESENTATIVE IN TOURNAMENT OF ROSES PARADE
PASADENA, CA
1986

FED EX ORANGE BOWL CHAMPIONS
MIAMI, FL
2004

ST. PETERSBURG FESTIVAL OF STATES
ST. PETERSBURG, FL
1982 1988

Ronald Graham

Graham, a graduate of Jamestown Community College and Baldwin Wallace College, has been an exemplary advocate for Jamestown area youth. In 1979, he and Dan Feather cofounded what became Chautauqua Striders, an organization "dedicated to the mentoring and guidance of youth through education, advocacy and athletics." Graham is seen here with students in the Lighted Schoolhouse mentoring program, which helps disadvantaged youth reach their potential. (Chautauqua Region Community Foundation.)

Infinity Visual and Performing Arts

Since Ron Graham founded the Infinity Visual and Performing Arts program in 1998, thousands of students have benefited from the opportunity to study music, art, theater, dance, performance, and puppetry at the Third Street facility. The Infinity Blues Project, shown here, performed at B.B. King's Blues Club in Memphis in 2009. The band members are, from left to right, David Nicastro, Joseph Teresi, Gavin Meade, Ian Kibbler, Kate Furman, Bella Buscarino, and Tommy Torcivia. (Jon Elder.)

Gunnard F. "Kinky" Kindberg

A 1950 graduate of Jamestown High School, Kindberg (1931–2006) married Carol Lind in 1959, and together they raised three children. Although he never actually drove a motorcycle, "Kinky" was instantly recognizable in his attire of jodhpurs with leather "puttees" on his lower legs, as seen here in 1987. Jamestown's "favorite street cop" directed traffic at the corner of Main and Third Streets for at least 20 of his 30 years on the police force, and he is remembered fondly by his family and friends.

Since Kinky spoke fluent Swedish, his widow recalls that Swedish visitors often came to "his" corner to speak in their native tongue. Many adults remember when, as children, the patrol officer gave them hard candy or gum and wanted them to think of the police as their friends. Scott Kindberg described his father as a larger-than-life role model who taught others many "unforgettable life lessons," including the importance of "doing the right thing even when no one was looking." Kinky's niece Maria touts him as a "Jamestown icon" who touched many lives. His son Gary recalled his father conducting bike safety programs at area school assemblies and serving as the police station's "public relations" tour guide.

Because he "loved all thing Swedish," Kinky was a dedicated member of the Thule Lodge, Vasa Order of America; the Norden Club; and the Ingjald Lodge #16, Order of Vikings. He served on the Salvation Army Advisory Board and on the board of the Scandinavian Studies Program at Jamestown Community College. In 1976, during King Carl XVI Gustav of Sweden's visit to Jamestown, he was part of the official security team.

For over 25 years, Kindberg annually donned his Santa suit and drove his sleigh to an equal number of organizations, to the delight of all. Not only is he missed by his large, close-knit family, but also by his extended family, the community he served and loved. (*Post-Journal*.)

Dudley "Spud" Ericson
The Michigan State graduate and former US Air Force captain established and managed, from 1964 to 1996, the human resources department at Jamestown's WCA Hospital. Ericson's longevity with several organizations is unequaled, including a 49-year association with the Jamestown chapter of the Red Cross and 41 years with the Rotary Club. A longtime member of the Norden Club, he recently celebrated his 50th year as a loyal member of the Vikings. (Dudley Ericson family.)

Paul and Martha Johnson
Generations of Swedish American families, including the Johnsons, seen here, have cherished their membership in the Ingjald Lodge #16, operated by the Independent Order of Vikings. While on the building committee, Paul Johnson, later club chief, helped acquire lake property adjacent to Midway Park for the lodge's clubhouse in 1945. With 1,840 feet of frontage, the 67-acre site remains one of the premier private picnic and recreational spots on Chautauqua Lake. (Eivor Johnson Gustafson.)

Norman A. Owen
A butcher known for his signature korvburgers, Owen takes great pride in his Swedish ancestry. In 2003, he received the Jamestown Community College/Scandinavian Studies Program Award of Merit for his contribution to Scandinavian culture. A momentous honor came in 2011, when King Carl XVI Gustaf, the reigning Swedish monarch, personally presented Owen and four others with certificates of appreciation from the Norden Club, of which His Majesty is an honorary member. (Owen family.)

Norden Club's 100th Anniversary
Norden Club members Durand Peterson (left) and Don Sandy proudly display the most coveted of Swedish awards, Order of the Polar Star medals, presented to them by His Majesty Carl XVI, Gustaf, King of Sweden, in October 2011. Peterson has worked tirelessly with Jamestown Community College to ensure that Swedish traditions are passed on to future generations, and Sandy has been the driving force behind Jamestown's annual Scandinavian Folk Festival. (Norden Club.)

A Royal Visit

During his first visit to Jamestown in 1976, His Majesty Carl XVI Gustaf of Sweden was made an honorary life member of the Norden Club, an organization formed in 1911 by several Swedish business, professional, and civic leaders to celebrate the culture and heritage they brought to their new home from their native Sweden.

King Carl XVI Gustaf, his wife Queen Silvia, and Jonas Hafstrom, the Swedish ambassador to the United States, graciously accepted the Norden Club's invitation to attend the club's 100th anniversary luncheon celebration, held at Jamestown Community College in October 2011. Members and invited guests were treated to Swedish music, dance presentations, award ceremonies, and the club's historic past.

Prior to their departure, the royal couple made a short visit to the nearby Roger Tory Peterson Institute of Natural History (RTPI), where King Carl XVI Gustaf had presented the prestigious Linnaeus Gold Medal to Swedish-American naturalist Roger Tory Peterson in 1976. Shown here in the lobby are, from left to right, Queen Silvia, King Carl XVI Gustaf, Mark Baldwin (RTPI director of education), and Jim Berry (RTPI president). (Norden Club.)

Roger Tory Peterson

The historic marker in front of Peterson's boyhood home in Jamestown summarizes his accomplishments: "World Famous Naturalist, Father of Bird Watching, Artist, Author, Educator." In addition, Roger Tory Peterson Institute president Jim Berry described his mentor as "the world's greatest interpretive naturalist." In 1934, Peterson's innovative and revolutionary bird-identification system was first published. *A Field Guide to the Birds* has helped millions of people to enjoy the natural world. (Roger Tory Peterson Institute.)

O. Gilbert "Gib" Burgeson

In 1957, Swedish naturalist Burgeson founded the Jamestown chapter of the National Audubon Society. Visiting Jamestown in 1976, Roger Tory Peterson attended the ground breaking of the Roger Tory Peterson Interpretive Center on its 214-acre lot south of the city. Both Burgeson Wildlife Sanctuary and Audubon's hands-on environmental education programs are assets to the region, as is the Allegany Nature Pilgrimage, an annual tri-state event in Allegany State Park, which Burgeson helped found. (*Post-Journal.*)

B. Dolores Thompson

In the late 1960s, Thompson, the daughter of Swedish immigrants and single mother of six, attended Jamestown Community College as a member of its first Potential of Women program, designed to provide older women a second chance at higher education. She then graduated from the State University of New York at Fredonia as a presidential scholar and Phi Beta Kappa member.

The selfless Thompson has had a full schedule for over 30 years, volunteering primarily as the City of Jamestown historian and a valued member of its Historical Marker Committee since 1978. She has also served as resource person and volunteer at the Jamestown Audubon Nature Center. From 1975 to 1982, she served as executive director of the Fenton History Center, and in 1984, she authored *Jamestown and Chautauqua County: An Illustrated History.*

Remarkably civic-minded, Thompson has played a critical role in a multitude of Jamestown organizations, including the American Association of University Women (AAUW), the YWCA, the Girl Scouts, the Women's Political Caucus, Fortnightly,

and the Scandinavian Studies Program. An accomplished musician, she has been a member of the Mozart Club string quartet and the Jamestown Concert Association, and is a supporter of the Chautauqua Regional Youth Symphony.

In 1982, Thompson was instrumental in establishing the Circle of Distinction as a way for the Jamestown chapter of the AAUW to celebrate Women's History Week (later changed to Month). Several of the 25 honorees, 19th- and 20th-century area women educators, physicians, civic leaders, attorneys, suffragists, and other pioneers who made noteworthy contributions to our cultural heritage, are found in this publication.

Thompson, a consummate role model and recipient of the Inter Club Council's Woman of the Year award in 1992, continued her crusade in a March 2012 article; it is, she wrote, "imperative that women support other women in all their endeavors to become educated and involved in all aspects of the educational, economic, business and political aspects of our society." (*Post-Journal.*)

The Franchina Family
Tony Sr. (left) and Tony Jr., both Falconer High School graduates, are master cobblers, a dying breed. Anthony J. Franchina began his apprenticeship in 1923, when shoemakers were plentiful. His son Tony and his grandson "Little Shoe" own shoe-repair businesses in Jamestown and Westfield, respectively, the only two in Chautauqua County. The father-son team's expertise, work ethic, and sense of humor continue to attract and maintain loyal clientele. (Jane Currie.)

Jim Roselle
A St. Lawrence University graduate affiliated with the WJTN/Media One radio station since 1953, Roselle is a member of the New York State Broadcaster's Hall of Fame and a staunch supporter of the Boys and Girls Club, the Lucille Ball Little Theater, and the James Prendergast Library. For "his civic affiliations and on-air promoting of the Chautauqua Region," he received the John D. Hamilton Community Service Award from the Chautauqua Region Community Foundation. (Douglas Spaulding.)

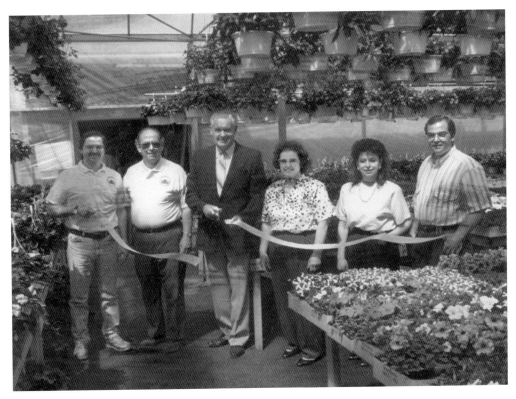

Brigiotta-Galbato Family
This May 1991 ribbon-cutting ceremony celebrated the opening of the Fairmount Avenue greenhouse, adjacent to Brigiotta's Farmland Produce and Garden Center. Shown here are, from left to right, Thomas N. Galbato Jr., Thomas J. Galbato Sr., Jamestown mayor Donald W. Ahlstrom, Frances Galbato, Carla Galbato Biber, and Timothy Galbato. In 2011, the firm was honored by the US Small Business Administration as one of the eight top small family-owned and -operated businesses in western New York. (Galbato family.)

Calamunci Family
Johnny's Lunch was established in 1936 by Johnny Colera. In 2011, his daughter Dianne (second from left) and her husband, Gus Calamunci (far left), celebrated the establishment's 75th anniversary. The restaurant was the "quasi-babysitter/training ground" for the third- and fourth-generation Calamunci children, now all actively involved in the industry. Son John (foreground) owns Hometown Grill; daughter Tammy Yezzi (second from right) is assisted by her sons Robert and Michael at her restaurant, Roberto's. Son Tony (far right), a corporate attorney, is the family business manager. (Calamunci family.)

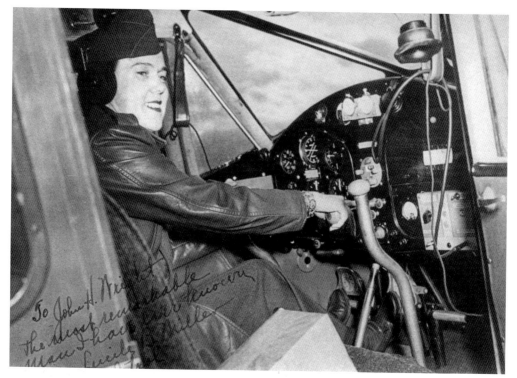

Lucile Miller Wright
Lucile Miller (1900–1990) graduated from George Washington University Law School, but she became a medical photographer and a licensed pilot. Hired as the private pilot for her second husband, John H. Wright, founder of the Jamestown Telephone Company, her aeronautical career spanned 51 years. Raised in Montana, she helped her adopted city found its municipal airport; as a tribute, the Lucille M. Wright Air Museum recently opened in downtown Jamestown. (Chautauqua Region Community Foundation.)

Bradley Anderson
Navy veteran and graduate of Syracuse University's School of Fine Arts, designer-turned-cartoonist Anderson's beloved canine Marmaduke's antics have been nationally syndicated in more than 500 newspapers since 1954. Anderson often summered in Lakewood with his mother's parents, Jonathan and Agnes Solomonson, whose family owned the *City of Buffalo* and the *City of Jamestown* steamers. Anderson's Midway Park memories have occasionally been reflected in his Fourth of July comic strip. (*Post-Journal.*)

Catherine Dickes Harris
Harris (1809–1907), a free black midwife and nurse born in Meadville, Pennsylvania, willfully harbored fugitive slaves in her Seventh Street home near the Jamestown boat landing. That location was also the site of the first African American church in Jamestown in 1881, which later relocated to 610 Spring Street. She is heralded for her courage, as few African American women dared maintain clandestine stations. Her legacy is memorialized in the sculpture tableau in Dow Park. (*Post-Journal.*)

Underground Railroad Tableau
Three life-sized bronze sculptures in Dow Park, created by David Poulin, commemorate the role played by Jamestown in the Underground Railroad movement. Featured are an anonymous barefoot runaway slave (pictured), Catherine Dickes Harris, and Silas Shearman, a "rabid abolitionist" conductor who sequestered fugitives in his Pine Street barn and arranged their passage to the next station en route to nearby Lake Erie and on to freedom in Canada. (Jane Currie.)

Vivian and Lula Taylor

This 2007 photograph shows Vivian (center) and Lula Taylor (left) receiving the John D. Hamilton Community Service Award from Randy Sweeney, executive director of the Chautauqua Region Community Foundation. After their marriage in 1950, the couple moved from North Carolina to Jamestown, where their presence has proved a blessing.

Vivian, a World War II veteran featured in *A Hometown Goes to War* by Rollie Kidder, graduated from the State University of New York at Fredonia in the 1970s and retired from the Marlin Rockwell Corporation after 35 years of service. Numerous organizations have benefited from Vivian's involvement, including the Lucile M. Wright Air Museum, the Civil Air Patrol, the Boy Scouts, and the YMCA. He also served as a Jamestown councilman for 24 years.

In addition to taking coursework at Jamestown Community College, Lula worked for 20 years at Proto Tool, a division of Ingersoll-Rand Company. "The diplomatic lady who listens to all" served as a five-term member of the Chautauqua County legislature, the first African American woman to be elected to any county legislature in New York State. Like her husband, Lula's schedule has been packed, as she has actively participated on the Chautauqua County Board of Health, the Chautauqua County Health Network Advisory Board, the Office of the Aging Advisory Board, and with Falconer Rotary.

Together, the couple founded the Chautauqua County Black History Committee and served on its Underground Railroad Tableau Steering Committee. They chaired the Jamestown Interracial Forum, and attend the Blackwell AME Zion Church. In 2003, they received the DeWitt Clinton Award for outstanding community service, the highest civilian honor bestowed by the Masonic Lodge. They humbly express their appreciation "for the opportunity" to better Jamestown and the Chautauqua region and, in return, have been honored by several grateful entities. Among Vivian's accolades are the Martin Luther King, Jr. Peace Award (1983); the Benjamin Spitale Lifetime Service Award (1997); and inclusion in *Who's Who Among Black Americans*. Lula received the YWCA Woman of Achievement and the DAR Women in American History awards in 2005 and 2008, respectively. (Chautauqua Region Community Foundation.)

Dr. Lillian Vitanza Ney
A graduate of Jamestown High School, Wells College, and the University of Buffalo Medical School, Dr. Ney (right) is pictured with mental health counselor Marianne H. McElrath (1935–2009), her "kindred spirit" for 40 years. Ney's affiliations with Jamestown's medical community, city government, and social organizations prompted New York state senator Catherine Young, at the dedication of the Lillian Vitanza Ney Renaissance Center, to describe Ney's life as one "defined by caring and community service." (Lillian Vitanza Ney.)

Kenneth and Lois Strickler
The Stricklers, ex-Pittsburghers, have spent over 50 years bettering their adopted hometown. The couple (right) donated their original Andy Warhol screenprint to the Weeks Gallery at Jamestown Community College in honor of Dr. Robert Hagstrom (left), who, with Lois, an accomplished watercolorist, helped establish its fine arts gallery. A founding member of the Jamestown Savings Bank and the Chautauqua Region Community Foundation, Ken is a well-respected businessman and volunteer extraordinaire. (Jamestown Community College, Weeks Gallery.)

Elizabeth "Betty" Smith Lenna Fairbank

In 1961, Betty Smith, the Louisville, Kentucky, native and graduate of Jamestown schools and Jamestown Community College, married Reginald A. "Reg" Lenna (1912–2000). After graduating from Lehigh University School of Engineering, her husband joined his father, Oscar, in the manufacture of automotive radiators at the Blackstone Corporation. Under Reg's leadership, the company expanded its product lines and entered the international marketplace in Sweden, Mexico, and Canada. During his 1976 visit to Jamestown, King Carl XVI Gustaf of Sweden awarded "the homegrown industrialist" the Royal Order of the North Star. Reg Lenna, a member of the Norden Club and the American-Scandinavian Heritage Foundation, and trustee of St. Bonaventure University, received the YMCA Lifetime Achievement Award and the John D. Hamilton Community Service Award from the Chautauqua Region Community Foundation.

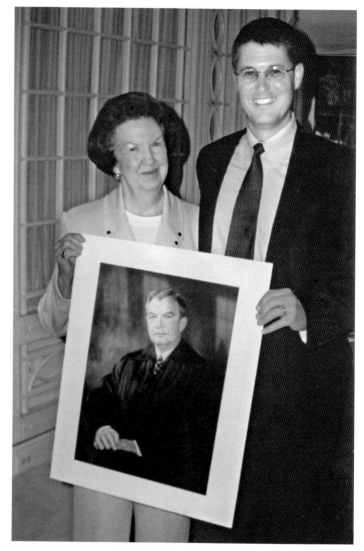

The Chautauqua Institution, Jamestown, and the Village of Lakewood benefited from the Lennas' peerless philanthropy. Betty continued the work after her husband's death and during her subsequent marriage to Joseph Fairbank, who died in 2010. Chautauqua Institution president Thomas Becker praised Betty as "a cheerleader for the region, taking great pride in the people and programs she helped to support and thrive." At Chautauqua, her accomplishments include the creation of the Elizabeth S. Lenna Recital Hall and the renovation of the Main Gate Welcome Center, the Catholic House, and the Packard Manor, her residence.

Betty (1923–2011) was a founding member of the Chautauqua Region Community Foundation and the Roger Tory Peterson Institute, and served on the boards of the Blackstone Corporation, the Reg Lenna Civic Center, and WCA Hospital. She was also a founding member and a primary benefactor of the Robert H. Jackson Center. In this photograph, Betty Lenna and John Q. Barrett, professor at St. John's University School of Law in New York City, hold a portrait of Robert H. Jackson. In his eulogy, Barrett, the center's Elizabeth S. Lenna Fellow and Jackson scholar, enumerated the connections between Betty and Robert H. Jackson: "Jamestown, education, hard work, opportunity, success. . . . What she wanted in supporting many other endeavors was to give the same chances to others . . . the spirit of her generous life is a lasting blessing." (Robert H. Jackson Center.)

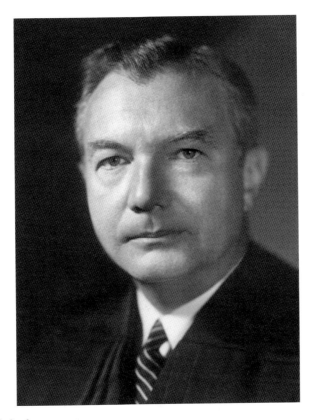

Justice Robert H. Jackson

A Frewsburg native and 1910 graduate of Jamestown High School, Jackson (1892–1954) spent only one year, 1911–1912, at Albany Law School, yet passed the New York Bar examination at age 21. His illustrious career began as a trial lawyer in Jamestown before moving to Washington, DC, as solicitor general and then attorney general of the United States. One of Franklin D. Roosevelt's "key assistants and personal favorites," many believe that Jackson would most likely have been a presidential candidate had Roosevelt declined another term. Instead, the associate justice of the US Supreme Court is revered as the chief American prosecutor at the Nuremberg war trials. The country lawyer's powerful and memorable opening remarks indicated that the proceedings would be a democratic trial rather than a lynching of the captured Nazis.

The Robert H. Jackson Center in Jamestown acknowledges the "radically changing face of international criminal law" and honors and fosters Jackson's legacy, which reflects the ideals he stood for during his lifetime: justice, fairness, and human decency. Greg Peterson, Jackson Center's former president and one of its founders, believes Jackson's relevance on an international stage "is not just history revisited but real and relevant to the global discussion of international justice and the rule of law."

Professor John Q. Barrett, a frequent guest lecturer at the Chautauqua Institution, notes Jackson's 50-year connection to the cultural center and its influence on him, noting that Jackson sat beside Pres. Franklin D. Roosevelt on the amphitheater stage during the latter's famous "I Hate War" speech in 1936. Like Betty Lenna Fairbank's appreciation "of alliances between community organizations . . . notably that between her beloved Chautauqua Institution and the Jackson Center . . . [and her desire] . . . to help them enhance each other's objectives," Peterson, Fairbank, and Barrett were all instrumental in the creation of the annual International Humanitarian Law Dialogs lectures, cosponsored by the Jackson Center and the Chautauqua Institution. Inspired by Jackson's legacy, renowned international prosecutors representing military tribunals held in Rwanda, Germany, Lebanon, Sierra Leone, The Hague, Cambodia, and the former Yugoslavia have gathered at Chautauqua for the past six years. (Robert H. Jackson Center.)

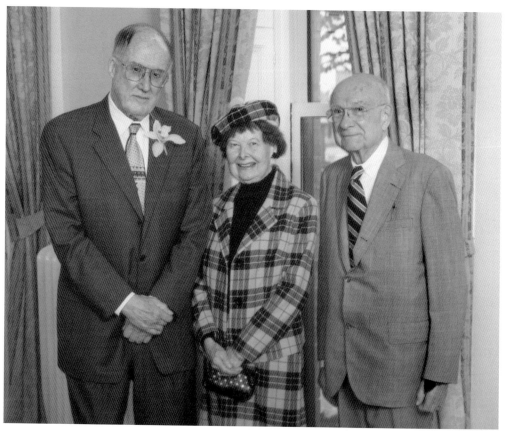

Stanley and Sarita Hopkins Weeks

Chief Justice William H. Rehnquist (left) joined distinguished community leaders Stanley A. (1912–2010) (right) and Sarita (1913–2004) at the Robert H. Jackson Center's dedication in 2003. They were photographed in the Weeks Room, the center's formal parlor, renovated and furnished through the couple's generosity. The Weeks Gallery at Jamestown Community College was a gift from Stanley Weeks in honor of his beloved wife. Both were cosmopolitan world travelers and art patrons. (Robert H. Jackson Center.)

Greg Peterson, "Preservationist for the Next Generation"

An athlete at Jamestown High School and Allegheny College, Peterson pursued a career in law. After graduating from the Dickinson School of Law in 1976, he returned home and remains a practicing partner in the Phillips Lytle LLP law firm. Honored with many prestigious awards, he is best known locally as an enthusiastic baseball historian and for his ardent allegiance to the Robert H. Jackson Center, which he cofounded. (John Elder.)

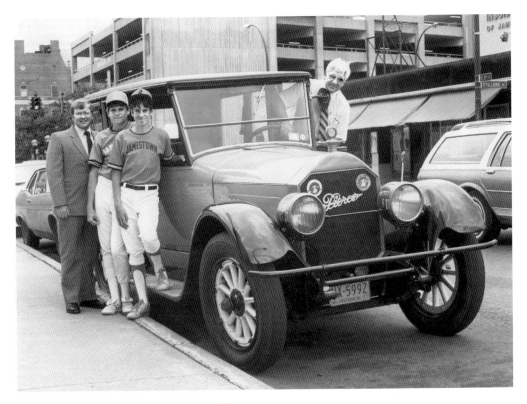

Russell E. Diethrick Jr., "Mr. Baseball"

Diethrick, proud of his Pennsylvania coal-mining family, graduated from Jamestown High School and worked at Marlin Rockwell Corporation for 12 years. There, he moonlighted as player, manager, and scorekeeper for the MRC Rollers, a semi-pro baseball team. While director of parks, recreation, and conservation from 1964 until 1999, Diethrick continued his involvement with youth baseball leagues.

In 1939, the area's first professional team, an affiliate of the Pittsburgh Pirates, joined the Pennsylvania–Ontario–New York (PONY) League to play ball at Celoron Park. In 1940, the team moved to Allen Park and, in 1941, found a permanent home at the new municipal stadium, located at the future site of Jamestown Community College.

Diethrick and Greg Peterson, baseball aficionados, convinced the Rich family, Buffalo Bison owners, to keep professional baseball in Jamestown by relocating its Niagara Falls Rapids franchise there in 1993. Numerous future major league players and coaches from affiliates of the St. Louis Cardinals, Los Angeles Dodgers, Atlanta Braves, Boston Red Sox, Montreal Expos, and Miami Marlins have delighted local fans while playing for Jamestown.

In the 1970s, Diethrick, chair of the Middle Atlantic Regional Babe Ruth Tournament, was instrumental in relocating that contest to Jamestown. Consequently, in 1980, the first 13-year-old Babe Ruth League World Series was held at the stadium. The series now shares the field with the Jamestown Jammers. Since then, players in the 13-15 and the 16-18 age divisions of the Babe Ruth Series have competed in Jamestown and stayed with host families.

In this photograph, Diethrick leans out of the car's driver's side. Standing are, from left to right, Charles Kent, an unidentified player, and Scott Ewing. Throughout the tournament, Les Ostrander, owner of Babe Ruth's Pierce Arrow automobile, added flair to the event by chauffeuring many participants.

In 1997, Diethrick was inducted into the Babe Ruth Baseball Hall of Fame, and the stadium was renamed Russell E. Diethrick Jr. Park. Both Diethrick and Peterson are members of the Chautauqua Sports Hall of Fame, which, under Randy Anderson's leadership, has greatly expanded. (Chautauqua Region Community Foundation.)

Mark Russell

Baseball enthusiast Russell poses at the Russell E. Diethrick Jr. Park with Pamela Berndt Arnold, official photographer for the 2003 and 2005 Babe Ruth World Series. When staying at his Chautauqua County residence, Russell often attends Jamestown Jammer games. Fittingly, in 2010, the "piano-playing political satirist" chose to conclude his 60-year career on the stage of the Chautauqua Institution's amphitheater, where he has appeared more times than any other performer. (Ann Berndt.)

Frank Hyde

Born in North Dakota, Hyde (1906–1984) began his career at the Jamestown *Post-Journal* in 1945. During his 35-year tenure as sports editor, his popular "Frankly Speaking" column kept readers apprised of the accomplishments of local athletes. The prestigious Frank Hyde Memorial Scholarship continues to assist an outstanding area high school senior athlete in his/her collegiate pursuit. Hyde's many memberships include the National Association of Baseball Writers and the Chautauqua Sports Hall of Fame. (Chautauqua Sports Hall of Fame, Jamestown, NY.)

Tara VanDerveer
VanDerveer, a Buffalo Seminary graduate and summer resident at Chautauqua, graduated from Indiana University in 1975, the year that Title IX was established, providing women equal opportunities in athletics. The acclaimed women's basketball coach transitioned from Indiana University, Idaho State, and Ohio State to Stanford University. In 1996, her USA women's team won a gold medal at the Summer Olympics in Atlanta. The Chautauqua Sports Hall of Fame takes pride in her accomplishments (Chautauqua Sports Hall of Fame, Jamestown, NY.)

Jim McCusker
In 1960, the Philadelphia Eagles defeated the Green Bay Packers for the NFL championship. Team members convened at a 50th reunion in 2010. McCusker (left), a Chautauqua Sports Hall of Fame member, stands beside Eagles head coach Andy Reid. The well-liked "hometown boy" and longtime owner of The Pub on North Main Street played with the Chicago Cardinals, Philadelphia Eagles, and Cleveland Browns, retiring in 1964 from the New York Jets. (McCusker family.)

Samuel Paladino
"A caring family man, raconteur . . . and involved citizen," Paladino (1924–2012) appeared in hundreds of roles on Jamestown stages, including a one-man retrospective of his theatrical life. Convinced that "the theater will give Jamestown one of the finest cultural assets in the country," the well-respected and debonair businessman successfully chaired the fundraising campaign that enabled the Lucille Ball Little Theater to find a permanent home in the vacant Shea's Theater building. (Paladino family.)

Reginald Lenna and the Civic Center
Originally a motion picture and vaudeville theater on East Third Street, the Palace Theater closed in 1981. Led by local visionaries, it was restored and reopened in 1982. A million-dollar pledge from the Reginald and Betty Lenna Foundation enabled the theater's total renovation and, in 1990, the Reg Lenna Civic Center materialized. Named to honor its benefactor, the center hosts performing arts and a vast array of community events. (Lenna Foundation.)

Lucy-Desi Museum

This museum, established in 1996 to honor Jamestown's "most famous daughter and adopted son," hosts thousands of visitors from every state and many countries, who travel to Lucille Ball's hometown to pay homage to the Queen of Comedy. The busiest weekends are the two annual celebrations: Lucy Fest, held on Memorial Day weekend; and Lucy's birthday gala in August. Relocated to 10 West Third Street, the museum features costumes, awards, family scrapbooks, photographs, and miscellaneous memorabilia donated by their children, Lucie Arnaz and Desi Arnaz Jr., and others. Interactive exhibits reveal the couple's personal histories, including interviews with some of Lucy's friends who stayed behind in Celoron and Jamestown while she headed to the lights of New York City and onto an enviable career in California.

The nearby Desilu Playhouse houses the *I Love Lucy* sets from the 50th anniversary nationwide tour in 2001–2002 in celebration of television's most-watched program. Exact replicas of Lucy and Ricky Ricardo's New York City apartment and their Hollywood hotel suite are on display, as is the Tropicana Room, Ricky Ricardo's nightclub, which is available for rental.

In 2011, the 100th anniversary of Lucy's birth, the Lucille Ball Desi Arnaz Center for Comedy was established, "to preserve [their] legacy . . . by enriching the world through the healing powers of love and laughter through our commitment to the development of the comedic arts." The ambitious Legacy of Laughter vision, endorsed by the Arnaz children, is comprised of four pillars: the annual Lucy Fest, a comedic arts education program, a comedy film festival honoring Lucy and Desi's legacy behind the camera, and the establishment of the first national comedy museum and hall of fame.

In 1946, the iconic Lucille Ball (1911–1989) offered this tribute: "They'll tell you that California is God's country, but God's country is right here in Jamestown. Think of the change of seasons, the gardens, the mushrooms, lilacs blooming in the spring—it's a wonderful, wonderful place, Jamestown, Celoron, the lake—that's why I had to come back." (Jane Currie.)

Natalie Merchant

A graduate of Westfield Academy and Jamestown Community College, Merchant has attained international success as a vocalist, lyricist, and recording artist. At age 17, she joined Jamestown Community College disc jockeys Rob Buck, Dennis Drew, and Steve Gustafson in their previously all-male band. Between 1981 and 1993, their band, 10,000 Maniacs, grew in stature. It toured throughout the United States and released two platinum and four gold recordings, including *In My Tribe* (1989), *Blind Man's Zoo* (1990), *Our Time in Eden* (1992), and *MTV Unplugged* (1993). In 2011, the band celebrated its 30th anniversary.

In 1994, Merchant left the group and shortly afterward launched her solo career with *Tigerlily*. The self-produced album sold more than five million copies. The young mother took seven years off and returned to her profession in 2010 with the double

album *Leave Your Sleep*, musical adaptations of 19th- and 20th-century classic and contemporary poetry dealing with various aspects of childhood, which she has performed internationally at art museums and poetry centers.

She received the Library Lion Award from the New York Public Library for her accompanying 80-page anthology, which featured the biographical sketches of the poets selected for her music project. On the New York Public Library website, Merchant acknowledges the merits of her hometown library: "As a young girl . . . it was my favorite place. . . . I spent countless hours between the shelves of [Prendergast] library. I remember being absolutely overwhelmed by what they contained." She candidly admits that the boxed set of Harry Smith's *Anthology of American Folk Music* that she discovered there "blew [her] mind and changed [her] life."

While the former member of the prestigious New York State Council on the Arts pledges support to global organizations including Greenpeace and Doctors Without Borders, Merchant's generosity continues to extend to character-building entities that fostered her own development: YAWACA, the YWCA day camp on Chautauqua Lake, the Jamestown YMCA teen center, and the "Way to Go" teen mentoring program of Jamestown's Winifred Dibert Boys and Girls Club on Allen Street, which is near her late Sicilian grandparents' residence. (Mark Seliger.)

CHAPTER SEVEN

The Lake's Lower West Side

Celoron lies on the lake's southwestern shore, about two miles west of the outlet at Jamestown in the Town of Ellicott. Originally named Sammis Point for Charles Wheeler Sammis, its first settler and the future son-in-law of Lakewood's founder, Uriah Bentley, the 67-acre settlement was purchased in the 1870s by James Prendergast, renamed Prendergast Point, and eventually inherited by his daughter-in-law Mary.

In 1891, Warren, Pennsylvania, businessmen purchased this swampland, later developed into cottage lots by their Celoron Land Company. The property was leased to Almet N. Broadhead's Jamestown Street Railway Company in 1894 for the creation of what would become an incomparable amusement and trolley park. Renamed to honor French explorer Pierre Joseph Celoron de Blainville and his expedition to the region, the village of Celoron was incorporated in 1896.

The village of Lakewood, Celoron's neighbor to the north, was incorporated in 1893. Large land tracts in the Town of Busti belonging to early settlers Gideon Gifford, Judson Southland, Uriah Bentley, Harridan Winch, and John Thomas Cowing were merged to form Lake View, its former name. Blessed with three miles of shoreline, Lakewood saw resort and residential development begin in 1870, when Cowing built the first of many hotels and steamer docks on the west side between Jamestown and Mayville. In 1873, the Cowing House became the Lakeview House, which in turn was replaced in 1889 by the exclusive Sterlingworth Inn. In 1880, the first Kent House, fashionable and easily accessed via its spacious dock, was sold for the grand sum of $35,000.

Celoron's population (1,295 in 2000) continues to be about four times larger than that of Bemus Point. Lakewood, similar in area to Mayville, has nearly twice the population of the county seat. Lakewood remains a residential community where locals and visitors can enjoy Richard O. Hartley Park, the site of outdoor concerts and holiday fireworks displays, and Lakewood Community Park, with its boat launch and picnic pavilion. To enhance its advantageous location, Celoron officials are currently in the planning stages of major waterfront development.

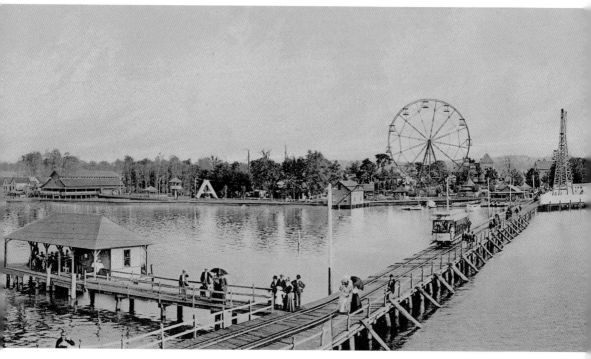

Celoron Amusement Park

The Jamestown Street Railway Company, owned by Almet N. Broadhead, leased 20 acres of the former Prendergast waterfront property to build "a playground for Jamestown and all creation." The attraction opened in 1894, and families arrived in droves by steamer, the Celoron-Fluvanna ferry, or on the double-decker trolley *Columbia* to indulge in the park's wondrous offerings: the Phoenix Ferris Wheel, Circle Swing, toboggan slides, arcade, and bathing beach. The site closed in 1962. (Sydney S. Baker.)

Lucille Ball Memorial Park

As a teenager, the comedienne lived on West Eighth Street (now Lucy Lane) in Celoron with Flora Belle and Fred C. Hunt, her maternal grandparents. She made frequent visits to the amusement park, obviously attracted by its Vaudeville theater, famous entertainers, and big bands. Upon her death in 1989, the park, which provides public access to the lake, was named in her honor and, in 2007, the Desi Arnaz Bandshell was constructed. (Jane Currie.)

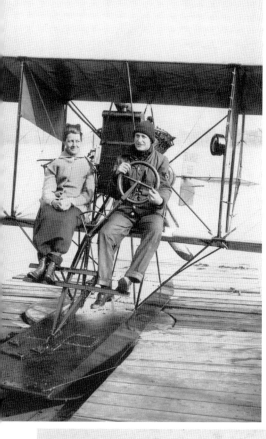

Al J. Engel

In 1914, Engel (right) made airmail history with *The Bumblebee*, his single-pontoon Curtiss Hydro aeroplane based in Celoron. He shuttled postcards daily between Celoron, Lakewood, Bemus Point, Chautauqua Institution, and Mayville. Although Chautauqua Lake Route No. 607004, the first regular airmail route in the United States, lasted for that summer only, Engel's plane is one of several classic vehicles on permanent display at the Crawford Auto-Aviation Museum in Cleveland. (William Reynolds III family.)

Excursion Ticket

Engel and his family lived at the Avenue Hotel in Celoron while he was under contract with the Celoron Amusement Park to perform exhibition flying skills, thrilling spectators by swooping low over the lake. As her ticket indicates, Jeanette Fenton Bailey Reynolds, seated beside Engel, was daring enough to climb aboard with him for a round-trip excursion from Celoron to Lakewood on August 31, 1914. (William Reynolds III family.)

No. 442 Date Aug 31 191 4

Aerial Navigation Company

EXCURSION TICKET
SKYLAND AND RETURN

This is to certify that Miss X. F. Bailey was on this date a passenger on the Hydro Aeroplane piloted by the undersigned.

From Celoron Park 2 trips To Lakewood and return

Aproximate distance 12 miles. Aproximate altitude 450 ft.

Signed Al. J. Engel

Aviator.

Amy King

The "popular down-to-earth" 1989 graduate of Southwestern High School is the only Chautauqua County citizen to die at the hands of terrorists. King (1971–2001) was the flight attendant on United Airlines Flight No. 175, the second plane that crashed into the World Trade Center on September 11, 2001. The annual Amy King 5K Run/Walk, initiated by her track coach, Tom Priester, benefits Amy's Playce at the Lakewood YMCA. (King family.)

Stewart "Stew" Snyder

Eight trumpet lessons from Arthur Goranson at Jamestown High School launched Snyder's 50-year career. He wrote all the arrangements for his well-known 12-piece "sophisticated swing" band that played at Celoron's Pier Ballroom prior to and following World War II. The group also delighted local audiences at Webb's Captain's Table, the Sword 'n' Shield, and the Fairmount Grill. Snyder (1918–2012) was inducted into the Chautauqua County Music Hall of Fame in 2007. (Maggie Scorse.)

Chautauqua Lake is the most deservedly popular Summer Resort on the American Continent, and one of the most important factors in its success is the superb transportation facilities afforded by the

Erie Railroad, The Picturesque Trunk Line of America.

The Main Line of the ERIE passes through
LAKEWOOD, the social and fashionable center of Chautauqua life,
and all through trains stop at Lakewood during the season, to which point the ERIE is the
ONLY line WITHOUT CHANGE from
NEW YORK, BOSTON, CLEVELAND, PITTSBURG, CINCINNATI, AND CHICAGO.

SOLID VESTIBULED TRAINS, PROTECTED EVERYWHERE BY BLOCK SIGNALS.
PULLMAN SLEEPING CARS, PARLOR CARS, LUXURIOUS DAY COACHES.

The ERIE is famous for the quality of the meals served in its Dining and Café Cars.

D. W. COOKE, General Passenger Agent, NEW YORK.

THE MATTHEWS-NORTHRUP WORKS, BUFFALO AND NEW YORK.

Erie Railroad Sign
The Erie Railroad Company's brochure specifically promoted Lakewood, New York, noting its resemblance to Saratoga Springs, with similar amenities for sophisticated travelers. While continuing to take meals and socialize with hotel guests, families increasingly sought privacy at adjacent cottages. By the 1920s, due to decreased patronage, summer residences began to replace the once-popular lakeside hotels. (Thomas Cowing.)

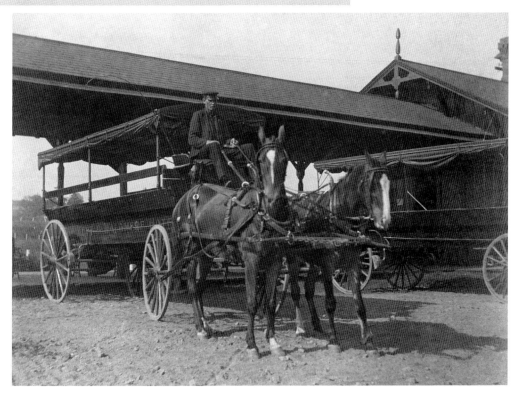

Baggage Master
Sheltered by protective sheds during inclement weather, passengers at the Erie Railroad depot waited for baggage masters like Ransom F. Cowing and this horse-and-buggy driver to facilitate their arrival at the nearby Kent House, Waldemere Hotel, and private docks. Lakewood's entire summer colony, served by both railroad and steamboats, flourished in the late 1880s and into the 20th century, attracting such celebrities as Pres. Theodore Roosevelt and John Philip Sousa. (Thomas Cowing.)

James Ward Packard

Two generations of the famous Packard family summered on Chautauqua Lake. In 1873, Warren Packard of Warren, Ohio, and his brother John from Meadville, Pennsylvania, "discovered" lovely Lakewood on the main line of the Erie Railroad system. They purchased the Lakeview House, built by John Cowing in 1870, and 25 surrounding acres and subdivided the shoreline tract into smaller cottage lots.

In the 1880s, Warren's son and business partners, James Ward and William Doud Packard, established successful companies in Warren, Ohio: the Packard Electric Company, manufacturer of dynamos and lamps; and the New York & Ohio Company, manufacturer of light bulbs, later sold to the General Electric Company. An 1884 mechanical engineering graduate of Lehigh University, James Ward, owner of over 800 patents, and his brother created the first Packard automobile in Warren, Ohio, in 1889. Together, they continued real estate development in Lakewood and built identical lakefront cottages on the eventual site of the Packard Mansion.

In 1912, James Ward and his wife, Bess, moved into the Packard Mansion, their elegant residence, a Georgian-style brick and stone home. Formal and cutting gardens, a greenhouse, two garages, a chauffeur's house, and servant's quarters were also located on the estate. Packard's boathouse stored his classic 45-foot mahogany yacht, on which he entertained Chautauqua Institution visitors Thomas Edison, Harvey Firestone, and Henry Ford, in addition to Jamestown's Robert H. Jackson. In 1917, his older brother, William Doud, built his Packard Manor on the Chautauqua Institution grounds. The home was restored in 1999 by owners Reginald and Betty Lenna. After Mrs. Packard's death in 1960, the Packard Mansion in Lakewood was converted into the Packard condominiums. The 100th anniversary of the mansion was celebrated in August 2012.

According to former Lakewood historian Helen G. Ebersole, J.W. Packard (1863–1928), seen here sitting behind the steering wheel of an early Packard automobile, and his wife were a "community-minded, beneficent family" whose generous gifts included the land for the Lakewood Village Hall and a Model T Ford chemical fire truck. "The presence of the Packard family remains a warm reality in the village beside the lake." (Lakewood Historic Museum.)

Elizabeth "Bess" Gillmer Packard
Bess Gillmer (1871–1960), a Vassar graduate, married
James Ward Packard in 1904. After his death in 1928,
she became a permanent resident of the small village.
Serving on the boards of Jamestown's WCA Hospital
and Boys Club and the Lakewood School Board, she
donated lights for the latter's high school athletic
field, the first one in western New York to be lighted
for evening football. She also provided funds for the
new Southwestern School's athletic field. (Lakewood
Historic Museum.)

Katherine "Kate" Stoneman
Kate Stoneman (1841–1925), daughter of
Busti's George and Katherine Cheney
Stoneman, created this silhouette. An
1866 graduate of Albany State Normal
School, the avid suffragist taught 40 years
before becoming, in 1855, the first female to pass the
New York State Bar exam. Not until she fought against
gender discrimination, however, would she be New
York's first woman lawyer, and, at age 57, the first
female graduate of Albany's law school. (Lakewood
Historic Museum.)

Davidson's Restaurant
In 1950, Bob and Margrete Davidson (pictured) opened Davidson's drive-in on Fairmount Avenue. The establishment featured charcoal-cooked hot dogs. Booths and carhop service were added in 1955. In 1987, their son Ron and his wife, Linda, assumed ownership, and, 25 years later, third-generation family member Leslie Davidson Genareo is the owner of the family business. The ever-popular eatery, serving over four tons of its signature fish monthly, celebrated its 60th anniversary in 2011. (Davidson family.)

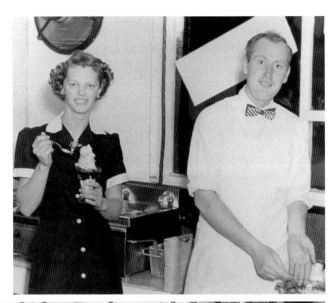

George and Anthony "Tony" Barone
George Barone (left) and his son Tony spent a combined 103 years as pharmacists at their Lakewood Drug Store on Chautauqua Avenue, which doubled as a popular soda fountain/gathering place for local teenagers. Tony, a lifelong Lakewood resident, takes enormous pride in Notre Dame University, his alma mater, and in his current roles as Lakewood Village historian and director of the newly established Lakewood Historic Museum. (Barone family.)

Helen Good Ebersole

Helen met her future husband, Glen, at Juniata College in Huntington, Pennsylvania. They moved to Lakewood in 1963 when Glen began his medical practice in radiology in nearby Jamestown. For her master's thesis at the State University of New York at Fredonia, Helen researched the development of the Jamestown Municipal Power Plant. Her work was published in 1973 as *Electricity and Politics in Jamestown, N.Y.*

For many years, Lucy Darrow Peake (1888–1968), a 1908 Syracuse University graduate, was the Town of Busti's historian and Lakewood schools librarian. In 1950, she wrote *The History of Lakewood* and, 10 years later, *The Biographies of the Early Families of the Town of Busti, Chautauqua County, New York*. In 1960, she also helped establish the Lakewood Memorial Library on West Summit Street.

Helen G. Ebersole, Peake's successor, has devoted her talents to the betterment of the village of Lakewood and the Chautauqua Lake region in general. For 10 years,

Helen was president of the Fenton History Center in Jamestown and then was the Village of Lakewood historian. During those tenures and afterward, she has authored numerous and varied local historical accounts and books, including *Chautauqua Lake Hotels* (1992) with Victor E. Norton; *One Hundred Years in Lakewood, New York* (1993); *Trolleys of Jamestown and Chautauqua Lake: A New Look* (1999); *An ImPRESSive Record: Jamestown Journal 1826–1941* (2008); and, most recently, *Off the Pedestal: Robert Jackson in Jamestown, 1909–1934* (2012).

Helen also chaired the Lakewood Memorial Library's successful renovation and expansion, dedicated in 2009 and, the same year, she received the John D. Hamilton Community Service award from the Chautauqua Region Community Foundation. Working with Tony Barone, her successor as village historian, she was instrumental in founding the Lakewood Historic Museum, which opened in the basement of the Anthony C. Caprino Municipal Building in October 2010.

Helen's personal observation and frustration resonate with other record keepers; "It's a very disconcerting thing to get old . . . ask questions . . . find nobody's older than you to answer. . . . How do we know if nobody tells us?" Thus, the vital role historians play in preserving the past for the generations that follow. (John Elder.)

Anthony C. "Tony" Caprino
Caprino (1929–2011), a Northwestern University Law School graduate and Lakewood police chief, served as mayor of his beloved village from 1979 until his death. Under his leadership, Route 394 was rezoned for commercial businesses, shared services with the Town of Busti were initiated, and the Rod and Gun Club was rebuilt. In 2011, the former Lakewood Village Hall was aptly renamed the Anthony C. Caprino Municipal Building. (Chautauqua Region Community Foundation.)

Lenna Clock Tower
Mayor Caprino helped initiate the revitalization of Lakewood's "downtown" district on Chautauqua Avenue. This main artery, which connects Route 394 with the lake, is fronted by an array of eclectic businesses, including boutiques and restaurants. Constructed in 2002, this clock tower, situated sentry-like at the village's main entrance, was gifted by the Lenna Foundation to honor the couple's continued generosity to their "hometown." (Jane Currie.)

CHAPTER EIGHT

The Lake's Upper West Side

In 1806, William Bemus bought several hundred acres of land on both sides of "The Narrows." Tom's Point, to the north, is named for the place where his son Thomas built his cabin in 1806 before he wed Mary Prendergast, sister of Jamestown's founder. Cheney's Point, to the south, honors Jonathan Cheney, whose family was the first to purchase land between Stow and Ashville. Both entities were initially located in Harmony, Chautauqua County's largest town, but because of its unwieldy size, in 1918, a parcel of those 86 square miles was broken off to form the Town of North Harmony.

The families of Daniel Carpenter and Myron Bly were among the earliest settlers in Ashville, situated in the southeast corner of the town. In 1808, pioneer Reuben Slayton Jr. built a sawmill and gristmill three miles west of Chautauqua Lake and, in 1824, became the supervisor of the Town of Harmony. By the early 1820s, Slayton's Corner's, renamed Ashville for its multiple asheries, boasted a post office, several shops, and McClellan's tavern.

Around 1818, the elder John Stow, whose family had emigrated from England, settled in the Town of Busti. His daughter Sarah and her husband, Adolphus Fletcher, resided in Ashville. There, Fletcher built a store and ashery before he established the *Jamestown Journal* in 1826. Sarah's brother John, for whom Stow was named, built his homestead there in 1868.

Unlike Bemus Point, Stow has yet to enhance its ferry landing commercially, but receives plenty of traffic due to its proximity to the Veteran's Memorial Bridge, the Bemus Point–Stow ferry, and the Stow farm, "one of the most important fish and wildlife habitats on Chautauqua Lake." The waterfront that stretches from Tom's Point south to the Ashville Bay Marina continues to be an oasis for fishermen and other outdoors enthusiasts. Chautauqua Lake's upper west side, with its valuable wetlands, has retained its rural characteristics. Several lakeside communities, including Victoria, Hadley Bay, Quigley Park, and Niets Crest, dot its shore.

Fardink Sawmill
The first sawmill in Ashville was built by pioneer Reuben Slayton Jr. in 1809. The sawmill shown here was inherited by Frank Fardink (1882–1968) from his father, Garrett, who built it in 1888. Operated later by two of Frank's five sons, Ernest and Albert "Dutch," it was located near the mouth of Goose Creek, the present-day site of the Ashville Bay Marina. In addition to the family's lumbering business, the Fardinks operated an adjacent dairy farm. (Fardink family.)

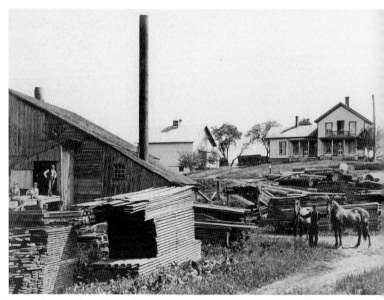

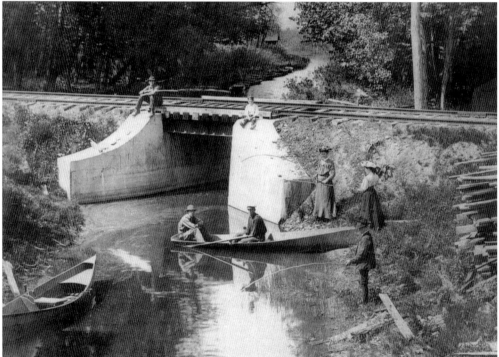

Goose Creek Mill Race
Sawmills were essential to the area's economic growth; dense forests had to be cleared and converted into productive farmland. From the Goose Creek site near the old Chautauqua Traction line, logs were floated downstream about a quarter of a mile from Ashville via the mill race. The logs then reached the creek's outlet beside the Fardink Mill on Chautauqua Lake. Like the pleasure-seekers shown here in the early 1900s, contemporary trout fishermen enjoy outings to this well-stocked creek. (Fardink family.)

LLAMA Club
"A bunch of guys hanging out together" purchased land in Ashville for a clubhouse and softball field. For 35 years, the Lower Lake Area Men's Association (LLAMA) has sponsored athletic and fundraising events to benefit community members. Shown here are, from left to right, Jim Lenart, John Spina, Pat Catanese, Gary Jensen, and Chuck McDonnell. Spina holds a Rich Stadium jacket presented to members of the Panama High School football organization after their 1982 sectional win. (LLAMA.)

Jackie Francis
Adjacent to Goose Creek, the Great Lakes Feed Company (GLF), built in 1913, has been operating since 1991 as the Ashville General Store. Owner Jackie Francis has transformed it from a grocery store into a popular eatery where customers can sit down to enjoy the unique menu items or order for takeout. In 1992, Francis, antique shop owner Bob Beckstrom, and several Town of North Harmony administrative staff initiated the annual Ashville Day event. (Jane Currie.)

Albert Warren Brown

The former Marine received his PhD in social sciences from Syracuse University's Maxwell School of Citizenship and Public Affairs in 1952. At both Eastern Illinois and Eastern Michigan Universities, he was a member of the geography and geology departments. The third president of the State University College at Brockport, from 1965 until 1981, Brown was praised for his extraordinary vision, leadership, and management style. In May 2006, the Albert W. Brown Building on campus was named in his honor. The accompanying plaque reads: "His visionary leadership provided quality educational opportunities to the broadest possible cross-section of students, and brought to this campus the faculty, programs and buildings that form an enduring monument to his success."

During Brown's tenure, the college developed physical education programs for the disabled, "an underserved population" who were finally beginning to be assimilated into society. A model for adaptive physical education programs that included research and professional preparation of that service was begun there in 1966. It is the longest-running program in the country and a leader in the field. As a result, Brockport College, the host site for the 1975 and 1976 New York State Special Olympics Games, was selected to host the Fifth International Special Olympics Games in August 1979. Shown here in attendance at the games are, from left to right, New York governor Hugh Carey, US senator from Massachusetts Edward Kennedy, New York state senator Patrick Moynihan, and college president Brown. Eunice Shriver was also on hand to cheer on more than 3,500 mentally challenged individuals.

Retiring to Connelly Park near Stow in 1985, Brown served as Jamestown Rotary Club's president from 1989 to 1990, received the Outstanding Forest Landowner Award from the region nine Forest Practice Board, and, while on the Town of North Harmony board, he was a member of the Chautauqua Lake Local Waterfront Revitalization Committee.

Brown's "irrepressible and infectious sense of humor and seemingly inexhaustible reservoir of positive energy and enthusiasm" is remarkable. Referencing Special Olympics athletes, Shriver was unknowingly describing the optimistic Brown, too, who now battles blindness. "It is invincible spirit which overcomes all handicaps . . . with it, there is no defeat." (Albert W. Brown.)

Elmer Stow

Stow (1836–1917), shown here, was a member of the dairy-farming Stow clan who arrived in the region around 1818. He lived on the 68-acre family homestead for nearly 60 years. While his son Sterling (1881–1964) became a dealer in hides and furs with an office in New York City, several of Elmer's descendants have contributed to the Stow community as postmistresses and members of the fire department and town board. (Stow family.)

Stow Post Office

In 1880, the Bemus Point post office, located on the west side of "the Narrows," was renamed the Stow Post Office. Before it burned down, the building shown here doubled as the residence of postmaster Orville E. Stow, his wife, Maie A., and their daughter Ruth. The former Chautauqua Traction trolley station, which, after 1904, serviced the small community and the nearby Victoria Hotel, remains in business as Stow's present-day post office. (Stow family.)

Bemus Point–Stow Ferry

William Bemus used rudimentary boats to transport people, animals, and goods across the Narrows from 1806 until 1811, when his son Thomas (1786–1829) obtained a license to operate a ferry. This c. 1937 photograph, taken from the western terminus at Stow, shows the *City of Jamestown* (left), the 1928 ferry built by Alton Ball (center), and the Village Casino in Bemus Point. Remarkably, the ferry remains in operation more than 200 years after its first run. (Sydney S. Baker.)

Alton W. Ball

Around 1900, Alton Ball (1872–1942) purchased the Bemus Point–Stow ferry, which became a family business involving his father, William, and his son Gerald. In 1902, he significantly upgraded the "hardy little conveyance" by replacing its hand-cranked pulley system with a naptha-fired steam engine that propelled the ferry along steel cables. During his 42 years of ownership, the distinguished-looking "old salt" was surely a goodwill ambassador for his lake and region. (Chautauqua County Historical Society.)

Arthur C. Thomas

Thomas (1923–2011) graduated from East High School, attended Case Western Reserve University, and worked for the Standard Oil Company, all located in Cleveland, Ohio. In 1950, he and his wife relocated to Chautauqua County, where the former World War II navigator began a 35-year career at the Marlin Rockwell Corporation in Jamestown.

Thomas immersed himself in his adopted community of Stow, his wife, Jean Graham Thomas's, hometown. He served as the Town of North Harmony justice from 1964 to 2008, as councilman from 2009 until his death, and was twice honored as Chautauqua County Citizen of the Year. With his sons and grandsons, Thomas was active in the Allegheny Highlands Council of the Boy Scouts of America, from which he received the Silver Beaver Award for his meritorious service.

Thomas was fascinated with the Bemus Point–Stow ferry, "an amusement ride," that, in reality, was "an integral part of life" for Chautauquans. Thomas and two of his grandsons piloted the ferry; other family members worked as toll collectors. From its inception in 1811 until 1982, when the Veteran's Memorial Bridge was opened, the ferry was a vital link in the county's highway system, transporting passengers 968 feet from one shore to the other, "averaging on a busy summer day, 80 trips, carrying about 350 automobiles." Although it made infrequent crossings after 1982, the legendary ferry, one of two Chautauqua Lake historic vessels still in operation under the auspices of the Sea Lion Project Ltd., continues to be a tourist favorite.

His personal affiliation and the wealth of information collected by his mother, a former Town of North Harmony historian, inspired Thomas to spend the last three years of his life researching, interviewing, organizing, writing, editing, and rewriting *A Ferry Tale*, an in-depth, homespun narrative that chronicles the history of the iconic Bemus Point–Stow ferry. Sadly, Thomas died within days of the book's publication and was noticeably absent at the ferry's bicentennial celebration in 2011. His family and friends, however, take enormous pride in his accomplishment and the legacy he selflessly gifted to the entire Chautauqua Lake region. (Thomas family.)

John Jablonski III
One of several environmentally concerned residents who helped found the Chautauqua Watershed Conservancy (CWC), Jablonski has served as its executive director for 20 years. Educated at Cornell University and the University of Wisconsin in the areas of natural resources, specifically fisheries, and regional planning/water resources management, Jablonski possesses dedication and experience. Along with his colleagues, he has been an exemplary steward of the Chautauqua Lake watershed. (John Jablonski.)

Stow Farm Property
In 2002, the Stow family, through the efforts of the Chautauqua Lake Watershed Conservancy, sold 18.6 acres of their property on Route 394 to New York State. This public-private partnership was created to preserve the natural habitat of muskellunge, black bass, wood ducks, and mink and to provide public access for fishing, wildlife observation, and environmental education. To date, the CWC has successfully conserved two miles of Chautauqua Lake's shoreline. (Jane Currie.)

Georgia Buck Sullivan
Sullivan was affectionately knows as the "Guardian Angel of Magnolia." Bedridden with arthritis for 50 years, she spent her days lying by her front window. Facing what is now Route 394, she waited for "friendly horn salutes by passing motorists." The Southernaires, a radio and concert quartet, even stopped at her home to perform en route to an engagement in Jamestown. (Kathleen Sullivan Crocker.)

Helen O'Connor
In 1933, J.V. O'Connor opened a horseback-riding camp at Cheney's Point that catered to well-to-do children of Pittsburgh families. Upon his untimely death, his wife, Helen, literally "took up the reins" to support her six children and surprised herself when she became a successful businesswoman. Westfield native Virginia Hopson Griffin, whose father provided the saddle horses, has fond memories of time spent at Camp Ronnoco with O'Connor. (Virginia Hopson Griffin.)

Roger Anderson

Anderson (1929–2004), a Jamestown High School graduate, abandoned his insurance career to operate Camp Chautauqua from 1968 until 2004. An innovator in the field of outdoor recreation, he was a member of the National Association of RV Parks and Campgrounds Inc., the New York State Tourism and Advisory Council, and the Campground Owners of New York's Hall of Fame. Moreover, he helped found the present-day Chautauqua County Visitors Bureau. (Mark Anderson family.)

Camp Chautauqua Lakefront

Since his father's death, Mark Anderson, known throughout New York State as a "dedicated champion of the outdoor recreation and hospitality industry," has continued to invest in the family's preeminent full-service camp, located between Stow and the Chautauqua Institution. In what is a year-round endeavor, Mark and his sons diligently maintain 300 sites on 100 acres. The camp, one of the largest individually owned pieces of property on the lake, has 2,000 feet of shoreline. (Mark Anderson family.)

CHAPTER NINE

The Chautauqua Institution

The pioneer Prendergast family purchased a 3,337-acre, contiguous tract of land on the west side of the lake near Mayville in the Town of Chautauqua. On August 4, 1874, the Chautauqua Assembly was founded by Lewis Miller and John Heyl Vincent as an idyllic camp meeting site for the instruction of Methodist Sunday school teachers. In 1879, Fair Point was renamed Chautauqua. With its advantageous location and accessibility by steamboat, train, and trolley, the popular summer retreat grew rapidly. It became a self-sufficient community with all of the conveniences of a large town, including a post office, grocery store, hotel, newspaper office, power station, waterworks, and sewage system.

Dr. Vincent's original concept of Chautauqua was as a place to promote intelligence and culture "in All Things of Life . . . Art, Science, Society, Religion, Patriotism, Education . . . whatever tends to enlarge and ennoble." In his introduction to Vincent's 1886 publication, *The Chautauqua Movement,* Lewis Miller added his intentions: "It was the purpose that the scientist and statesman, the artisan and tradesman, should bring their latest and best to this altar of consecration and praise; that the tourist and pleasure-seeker should here stay and find their best place for reveries; when thus strengthened, to return to their respective fields, and there, through the year, weave into the fibre of the homework the newly gathered inspiration and strength . . . in the midst of great problems and struggles . . . Chautauqua must perform her part. The churchman, the statesman, the humanitarian, must be brought on her platform, and there, free from caste and party spirit, discuss questions, solve problems and inaugurate measures that will mould and inspire for right."

During its nine-week summer season, the nearly 140-year-old Chautauqua Institution continues to embrace the founders' mission with its four pillars: Art, Education, Recreation, and Religion. Listed as a National Historic Landmark, the institution proudly serves all age groups and provides unlimited opportunities for self-improvement and lifelong learning. In the summer, the 750-acre gated, pedestrian community's population grows from 400 year-round residents to several thousand guests per day, with an annual total of 170,000 visitors. These guests greatly impact the Chautauqua Lake region's economy.

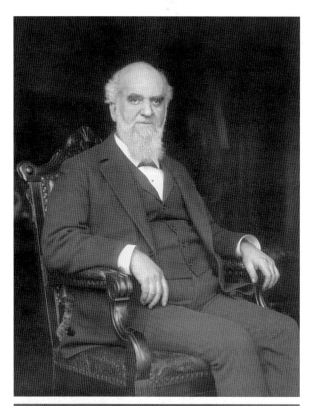

Lewis Miller, Cofounder
Former superintendent of Sunday schools in Akron, Ohio, Miller (1829–1899) was a respected industrialist, educator, and inventor who patented the Buckeye mower and reaper. He taught religious instruction at the Chautauqua Assembly and served as its first president, from 1874 until 1899. His friend Harvey Firestone believed Miller's "genius and ability in the field of science and a practical vision of the spiritual and education needs of America" aided Chautauqua's early success. (Chautauqua Institution Archives, Oliver Archives Center.)

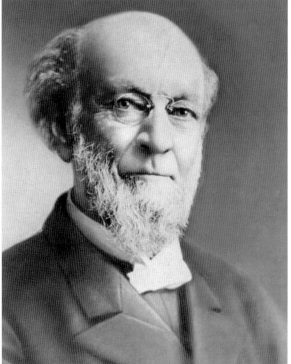

Bishop John Heyl Vincent, Cofounder
Born in Tuscaloosa, Alabama, Vincent (1832–1920) was an ardent teenage preacher who, in 1888, became a bishop of the Methodist Episcopal Church. As chancellor of the Chautauqua Assembly, he was a strong proponent of lifelong learning. In addition to his magnetic personality and effective oratory, fellow Methodist minister and longtime friend Jesse Lyman Hurlbut acknowledged Vincent's voice as that "of a leader, calling men onward toward the heights." (Chautauqua Institution Archives, Oliver Archives Center.)

Anna J. Hardwicke Pennybacker

An 1880 graduate of Sam Houston State Normal School and a Texas educator, Pennybacker (1861–1938) spent the summers of 1917 to 1937 at Chautauqua while she served as president of the Chautauqua Women's Club. The institution's first female trustee attracted distinguished women to its platform. Pennybacker (right) is seen here with her friend Eleanor Roosevelt, who invited members of the Chautauqua Women's Club to a White House luncheon in 1935. (Chautauqua Institution Archives, Oliver Archives Center.)

Mr. and Mrs. Thomas A. Edison

In 1886, Edison married Akron heiress Mina Miller, the daughter of the Chautauqua Institution's cofounder Lewis Miller. Chautauqua's educational environment was conducive to Edison's "hungry mind," and the Athenaeum Hotel there was one of the first public buildings to have electric lamps. During the summer months, Edison's much younger wife was active in the Chautauqua Women's Club, Chautauqua's Bird and Tree Club, and in the beautification of the grounds around their Miller Park cottage. (Chautauqua Archives, Oliver Archives Center.)

Arthur E. Bestor

The association of Bestor (1879–1944) with Chautauqua, which lasted more than 40 years, began in 1905. That year, he was an educator and lecturer from the University of Chicago's extension program held on the grounds of the institution. His presidency, from 1915 to 1944, was rife with symposiums relating to global affairs. Bestor's reputation as an innovator in the field of education grew beyond the national to the international stage, as did Chautauqua's, for the caliber of its presentations and presenters, performances and performers. (Chautauqua Institution Archives, Oliver Archives Center.)

Arthur E. Bestor and Amelia Earhart

In 1929, Earhart, the renowned aviatrix and the first woman to fly solo over the Atlantic Ocean, was invited to lecture at Chautauqua. She landed her plane on the Chautauqua Golf Course prior to a luncheon at the president's home. Seen here with President Bestor, she delighted the 5,000 attendees at the amphitheater with details of her record-breaking trans-Atlantic flight as well as admirers anxious to glimpse "America's latest star." (Chautauqua Institution Archives, Oliver Archives Center.)

Dr. Daniel L. Bratton

Born in Nyack, New York, Bratton (1932–2001) graduated from Allegheny College in Meadville, Pennsylvania; Teachers College, Columbia University; and Gannon University in Erie, Pennsylvania. From 1959 to 1972, he oversaw student affairs at Adelphi University and the University of Maryland; for 10 years, he was president of Kansas Wesleyan University in Salina, Kansas. The seasoned educator and ordained Methodist minister was a perfect fit for the Chautauqua Institution, whose original purpose was to train Sunday school teachers. When he accepted the institution's presidency, Bratton was already familiar with Chautauqua from visits to his grandmother in nearby Westfield. From 1984 until 2000, Dr. Bratton found his niche while fostering Chautauqua's renaissance.

Former institution board member Cynthia Peterson thought Dr. Bratton "brought great change to Chautauqua while honoring its tradition . . . a deeply religious and selfless man who put others ahead of himself." Chautauqua historian Alfreda Irwin praised Bratton as a "man of outstanding rapport . . . who surrounded himself with capable staff and then stepped back to let them perform."

The five Chautauqua conferences on US-Soviet relations held between those two nations from 1985 to 1989 remain Dr. Bratton's greatest legacy. Held in Riga, Latvia; Tbilisi, Georgia; the University of Pittsburgh; and on the grounds of the institution, the "successful diplomatic exchanges" brought national and international acclaim to Chautauqua.

Between his retirement in 2000 and sudden death five months later, Bratton, as its first executive director, played a crucial role in the creation of Jamestown's Robert H. Jackson Center. Then in its infancy, the center needed to establish a connection to the Library of Congress, where Justice Jackson's papers had been donated by his family in the mid-1980s. Justice Sandra Day O'Connor and Dr. Bratton became friends at Chautauqua, and at their meeting in Washington, DC, O'Connor facilitated the center's access to the Library of Congress and to the Jackson papers for scholarly research.

Bratton was also on the boards of the county's Vacationlands Association, the Committee on Tourism, and the Jamestown YMCA. (*Post-Journal.*)

Judith Olson Gregory
Jamestown native, Alfred University graduate,
and summer resident at Chautauqua, Gregory is a
renowned visual artist who, for more than 20 years,
has exhibited nationally and locally, most recently at
Jamestown Community College. Former president of
the Chautauqua Center for the Visual Arts, renamed
the Visual Arts at Chautauqua Institution (VACI), she
has also received prestigious awards from the arts and
cultural community of Rochester, New York, where
she resides. (Frederick Gregory.)

Doris Goodrich Jones
With a degree in violin performance from Baylor
University, Jones, a Texan, continued music and drama
study in New York City. In 1934, she studied puppetry
at Chautauqua and created over 300 marionettes,
teaching workshops and performing during Old First
Night and at the Children's School. She was president
of the CLSC Alumni Association and of the Bird, Tree
and Garden Club, which her aunt Henrietta Ord Jones
helped found 100 years ago. (Chautauqua Institution
Archives, Oliver Archives Center.)

Olga Kaler

Kaler graduated from the New England Conservatory of Music after moving to the United States in 1992. In 1994, she met fellow Russian Ilya Kaler during a performance of the Chautauqua Symphony Orchestra. Now married, the couple are violin professors at DePaul University School of Music in Chicago and summer at Chautauqua, where Olga is a member of the symphony and Ilya teaches master classes at the School of Music. (Olga Kaler.)

Stephen R. Smith

An Erie, Pennsylvania, native and graduate of Oberlin College and Carnegie Mellon University, Smith recently celebrated his 40th season as a bassoonist for the Chautauqua Symphony. Following his career as band director and instrumental music teacher at nearby Cassadaga Valley Central School, Smith discovered another talent. A renowned watercolorist and outdoorsman, he is now deemed "one of the finest [half-model trophy] fish carvers in the world." (Pamela Berndt Arnold)

Maritza Morgan
Born in Zagreb, Croatia, Morgan (1920–1997) emigrated to the United States during World War II and, following her graduation from Cornell University in 1944, studied at the Art Students League in New York City. After her apprenticeship at New York's Museum of Natural History, she spent several years as artist-in-residence at Dartmouth College's Wilson Museum, Princeton University, and, simultaneously, at the Pittsburgh Theological Seminary and Chautauqua Institution. She eventually resided at the latter.

Inspired by Eastern European religious icons, the internationally acclaimed artist is recognized for her signature folk art, wood-carved paintings based on Biblical stories that, along with her oil and watercolor paintings, are found throughout the world in private collections, churches, and galleries.

First exhibited as part of Princeton Theological Seminary's 175th anniversary celebration in 1988, her large mural *Stories on Wood* was exhibited at Chautauqua's Hall of Christ in the summer of 1989 to celebrate the 100th anniversary of the Presbyterian House on the grounds. In the 1990s, Morgan completed two series of 12 paintings, both four feet by four feet, entitled *Children of Abraham* and *The Challenge of Noah's Ark*.

In 1996, Morgan and her partner, Robert Ludwig, traveled to Egypt. Their trip inspired her Pyramids for Peace collection, depicting the country's poverty and need for humanitarian intervention. The Hands Along the Nile exhibit was held at The Crary Art Gallery in Warren, Pennsylvania, just south of Jamestown, where Morgan had worked as feature editor of the *Times Observer*, played in the Warren Symphony Orchestra, and taught art at the high school before the death of her husband, physician Norman Charles Morgan.

While a resident of the Chautauqua Institution, the multitalented Morgan was a cellist, a staff member of *The Chautauquan Daily*, a Chautauqua Fire Department volunteer, and cofounder and manager of the Good Morning Farm Restaurant in neighboring Stow, New York. She also created a series of vibrant murals for the Children's Room at Smith Library on the institution grounds. (Rosemary Rappole.)

Warren L. Hickman

Born in Eden, New York, Hickman, a graduate of Colgate University, Columbia University, and the Graduate Institute of International Studies of the University of Geneva in Switzerland, is a resident of Trumansburg, New York, and Chautauqua.

Hickman has been an active Chautauquan since the early 1940s, when he was a counselor at the Boys Club. He served on the institution's board of trustees from 1957 to 1985 and, since 1951, has lectured on a vast array of topics at the Hall of Philosophy, the Hall of Missions, and on the amphitheater stage.

His association with the Chautauqua Literary and Scientific Circle (CLSC) has been representative of thousands of CLSC members who, since 1878, believed in the value of lifelong learning afforded by John Heyl Vincent's plan and were diligent in their pursuit of a CLSC degree. In 1941, along with his parents and his sister, Hickman enrolled in the CLSC's four-year guided reading program. After the other family members had read the required books, they bundled them up and sent them to Warren, who read the first year's selections while studying at Colgate University and the next three years' worth while serving in the Army at Fort Bragg, London, Versailles, and Reims.

The family's graduation was delayed a year so that they could march together as members of the CLSC class of 1945, following Warren's return home from the European theater. Shown here a year later near the Golden Gate are, from left to right, Warren, his sister Lucile Hickman Leonard, and his parents, Louise and Albert F. Hickman.

During World War II, Hickman was chief of the Top Secret File Section (Supreme Headquarters, Allied Expeditionary Forces) and was awarded a Bronze Star by Gen. Dwight D. Eisenhower. His academic career, begun in 1949, included positions in the fields of international relations, history, and political science at Ohio Northern University, Ithaca College, Syracuse University, Eisenhower College, and the Rochester Institute of Technology.

Fittingly, in 2012, the proud nonagenarian was tapped as the grand marshal of the CLSC Recognition Day Parade as well as the honoree of the CLSC class of 2012. (Warren L. Hickman.)

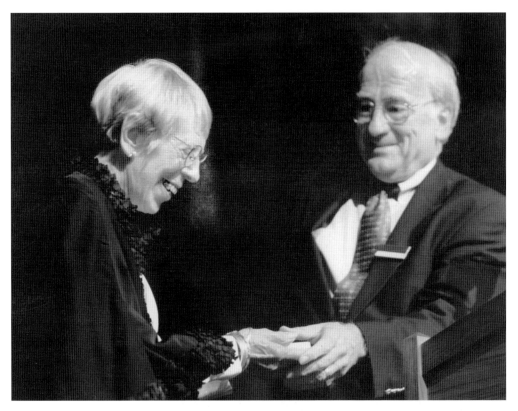

Alfreda Locke Irwin
Born in Dunkirk, New York, Irwin (1913–2000) attended school in Erie, Pennsylvania, and was a graduate of Ohio Wesleyan University, where she majored in English and journalism. While she and her husband, Forrest B. Irwin, resided in Franklin, Pennsylvania, with their six children, Alfreda was a reporter for the Franklin *News Herald* and gained recognition as a children's radio show host and storyteller. The daughter of a Methodist minister, Alfreda first visited Chautauqua with her grandparents. In the mid-1950s, the Irwins began their summer residency at their 39 Palestine Avenue cottage.

Alfreda's Chautauqua association began in 1958 as a reporter for the *Chautauquan Daily*, where she was editor from 1966 to 1981. Upon her retirement, she was named editor emeritus and soon thereafter was appointed the first official Chautauqua Institution historian. Her colleague June Miller-Spann, archives manager, praised Irwin as "an extraordinary woman . . . [who] elevated the significance of Chautauqua's history to a level that continues to create both pride and endearment to the place we love."

In 1970, Irwin wrote *Three Taps of the Gavel,* Chautauqua's history. In 1983, she founded the Chautauqua Network, a group of independent "chautauquas" around the country connected to the "Mother Chautauqua." As its director, she edited its newsletter and traveled extensively on its behalf.

She was the honoree of the CLSC class of 1993; in 1994, she was recognized by the National Women's Hall of Fame in Seneca Falls, New York; and, in 2001, she was honored as a "Woman of Distinction" by the Jamestown branch of the American Association of University Women.

Dr. Bratton was grateful for Irwin's "great knack for finding anecdotes, writings, speeches . . . to help him better understand Chautauqua, its people and its history." This photograph, from 1999, shows Dr. Bratton presenting the prestigious Chautauqua Medal to Alfreda, his dear and respected friend, who unassumingly labeled the occasion "the most glorious feeling."

Upon Irwin's death, Dr. Bratton intoned: "Fear not about the perpetuation of your work or the tasks left undone by your departure from us. Your legacy, your spirit, the force of our individual and collective memories of you will never let you go." (Irwin family.)

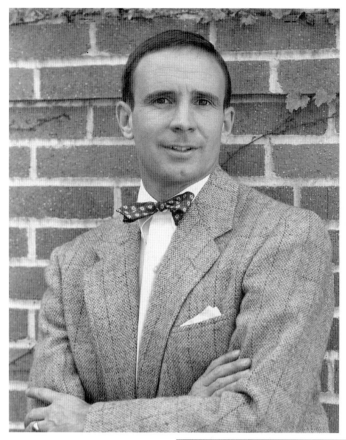

H. Richard Duhme
From 1947 until 1983, Duhme taught sculpture at Washington University in St. Louis. For two decades, he joined the Chautauqua School of Art faculty in the summers and was commissioned in 1974 to design the Chautauqua Medal, a commemorative piece for the institution's centennial celebration. Duhme's sculpture, entitled *Boy with a Recorder*, located behind Smith Library, is dedicated in memory of Benton Roblee Duhme and Warren Leggat Duhme. (Chautauqua Institution Archives, Oliver Archives Center.)

Chautauqua Medal
The coveted bronze and silver award, Chautauqua's highest honor, has been bestowed on a select few. Recipients directly associated with the institution have included centennial chair Miriam S. Reading; former presidents George L. "Shorty" Follansbee, Judge W. Walter Braham, Curtis W. Haug, and Daniel L. Bratton; and former trustees John D. Hamilton, Richard H. Miller, Howard G. Gibbs, Elizabeth S. Lenna, Richard Bechtolt, and Mary Frances Bestor Cram. (Jane Currie.)

BIBLIOGRAPHY

The Centennial History of Chautauqua County, Vol. II. Jamestown, NY: The Chautauqua History Company, 1904.

Chautauqua County Department of Planning and Economic Development website.

Darrow, Floyd L. *History of the Town of North Harmony, Chautauqua County; A Compilation of Book I and Book II.* New York. The Town Board of North Harmony, 1990.

Downs, John P. and Fenwick Y. Hedley. *History of Chautauqua County, New York, and Its People,* vol. II. Boston: American Historical Society Inc., 1921.

Ebersole, Helen G. *Good Ol' Days in Lakewood: One Hundred Years in Lakewood, New York.* Lakewood: Linda Cowan, 1993.

Ebersole, Helen G. *An ImPRESSive Record: Jamestown Journal, 1826–1941.* Jamestown, NY: The *Post-Journal,* 2008.

Erlandson, Thomas A. and Linda Voltmann Swanson. *Figure 8 the Lake: A Driving Tour of Chautauqua Lake.* Jamestown, NY: Eagles Publishing, 2003.

Hazeltine, Gilbert W., MD. *The Early History of the Town of Ellicott, Chautauqua County, New York.* Jamestown, NY: Journal Printing Company, 1887.

Moe, M. Lorimer. *Saga From the Hills: A History of the Swedes of Jamestown.* Jamestown, NY: Fenton Historical Society, 1983.

Moore, Sue Anne. *Village of Celoron Centennial, 1896–1996: Official Souvenir Booklet,* Celoron Centennial Committee.

Peake, Lucy Darrow. *History of Lakewood, New York.* Compiled July 1950.

Sherwin, Hetty. *The Early History of Fluvanna, Chautauqua County, New York.* Jamestown, NY: Journal Press Inc., c. 1925.

Stahley, Mary Jane. *History of Bemus Point.* Pamphlet, 1992.

Thompson, B. Dolores. *Jamestown and Chautauqua County: An Illustrated History.* Woodland Hills, CA: Windsor Publications Inc., 1984.

Young, Andrew. *History of Chautauqua County, New York: Biographical and Family Sketches.* Buffalo, NY: Printing House of Matthews and Warren, 1875.

INDEX

AN IMPRINT OF ARCADIA PUBLISHING

Find more books like this at
www.legendarylocals.com

Discover more local and regional history books at
www.arcadiapublishing.com